KNUTSFORD
& DISTRICT
THROUGH TIME
Paul Hurley

AMBERLEY PUBLISHING

Acknowledgements

I would like to thank Linda Clarke of the Chester Records office for her help in acquiring old photographs, Val Bryant of the excellent Heritage Centre, the staff of the Angel Hotel and Glynn Stockdale, owner of the Penny Farthing Museum, for his advice; and most importantly Fred McDowell for both allowing me access to his impressive archive and his invaluable help with the compilation of the book. I look forward to his book on the Knutsford Royal May Day. As usual, I would like to thank my lovely wife, Rose, for her patience during the not inconsiderable time it took to complete the book.

Author Information

Paul Hurley is a freelance writer, author and is a member of the Society of Authors. He has a novel, newspaper and magazine and local history credits and lives in Winsford Cheshire with his wife Rose. He has two sons and two daughters. Contact www.paul-hurley.co.uk

Books by the Same Author

Fiction

Liverpool Soldier

Non-Fiction

Middlewich (with Brian Curzon)
Northwich Through Time
Winsford Through Time
Villages of Mid Cheshire Through Time
Frodsham and Helsby Through Time
Nantwich Through Time
Chester Through Time (with Len Morgan)
Middlewich & Holmes Chapel Through Time
Sandbach, Wheelock & District Through Time

First published 2011

Amberley Publishing
The Hill, Stroud
Gloucestershire, GL5 4EP

www.amberley-books.com

Copyright © Paul Hurley, 2011

The right of Paul Hurley to be identified as the Author of this work has been asserted in accordance with the Copyrights, Designs and Patents Act 1988.

ISBN 978 1 4456 0610 1

British Library Cataloguing in Publication Data. A catalogue record for this book is available from the British Library.

Typeset in 9.5pt on 12pt Celeste.
Typesetting by Amberley Publishing.
Printed in the UK.

Introduction

Knutsford is an ancient town with an interesting history and some quite extraordinary buildings. Much like other nearby North Cheshire towns, Knutsford has its quota of wealthy inhabitants. Accordingly there are many high class shops and restaurants. If ever there was a need for pedestrianisation it is here: King Street, better known locally as Bottom Street, with Princess Street (Top Street) running parallel. The street is one-way, with Princess Street one-way in the opposite direction. More details can be found within of some of the interesting buildings in the town centre, but two worthy of mention here are the Gaskell Memorial Tower, dedicated to the famous Knutsford author Elizabeth Gaskell who used the town and its characters in her novels (including *Cranford*, which became a successful TV series); and, next door, Kings Coffee House. Both were built by the somewhat eccentric Richard Harding Watt in 1907/08. The many buildings of Watt – a Manchester glove maker – are a strange addition to this pretty Cheshire market town. He was well travelled and decided to bring some of the ideas from countries he visited and he then had them replicated in Knutsford. Legh Road has many of his creations in the form of Italianate dwelling houses. He also built the large laundry and Ruskin rooms in Drury Lane, including some Moorish influences with minarets, domes and towers. Not everyone in Knutsford was enamoured with these fantastic buildings, Nicholas Pevsner described the creations as 'the maddest sequence of villas in England!'

The home of Elizabeth Gaskell can be found in the street named after her, Gaskell Avenue, and further down this short road is Heath House, where once lived the highwayman Edward Higgins, or 'Squire' Higgins as he was known. The same house in 1741 was occupied by Mr Charles Cholmondeley, a well known Cheshire personage and it was also known at one time as the 'Cann Office', as scales and weights were tested here.

But going back a little further, the town is mentioned in the Domesday Book and, although there are many different suggestions as to the origins of the name Knutsford, it would appear that King Canute features quite strongly. One unusual tradition is to 'sand' the streets for weddings and other functions. Tradition has it that this originated when Canute, after fording the river, shook the sand from his shoes in the path of a wedding party. Now it is carried out during the Knutsford May Day – or should I say the Royal Knutsford May Day as it is allowed to use the term 'Royal' in its title. This honour was bestowed on the event by the Prince and Princess of Wales in 1887, twenty-three years after the introduction of the May Day festivities. This procession leads to Knutsford Heath, a large grassed area in the town that once boasted the Knutsford race course with its intricate grandstand. The heath gained modern notoriety with a standoff between prospective MP Martin Bell, and Neil and Christine Hamilton. The parliamentary constituency of Tatton now has the Chancellor of the Exchequer, George Osborne, as its MP.

Also in the town could be found the large Knutsford prison, which was fronted by the still extant Sessions House; both built 1817 to 1818. The prison existed through the very draconian sentencing that prevailed in the 1800s, Transportation for six years for a minor theft was not unusual and the prisoners were housed there prior to this. Eventually there was accommodation for up to 700 prisoners and the prison was equipped with a gallows, treadmill, birch, cat o'nine tails and crank machine for punishment. The prison went on to be a military detention centre and spent a time as a training centre under the Revd Tubby Clayton of Toc H fame, who for a short time trained ex-servicemen for ordination. The buildings were used to house homeless families after the First World War, and were demolished in 1934 apart from the Session House, which later became Knutsford Crown Court.

This is simply a taste of what can be found in this book, so enjoy this Cheshire gem of a town. See how things once looked – in one case as far back as 1865 – and what the same scenes present you with today.

All of the modern photographs were taken in late summer 2011 by the author.

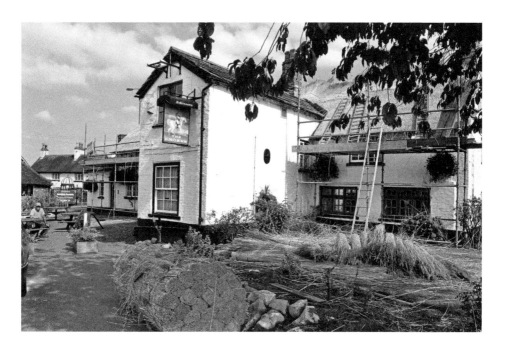

The Smoker, Early 1900s

Cheer up anti-smokers: the name has nothing to do with the nasty habit! In this case, the name 'Smoker' refers to a white charger of that name bred by the Prince Regent. The horse was owned by the first Lord de Tabley when he formed the Cheshire Yeomanry to assist in the defence of the country against Napoleon. The noble lord can be seen mounted on Smoker on the pub's name board, along with the cup the horse won in 1792. What better time to take a modern photograph than when the roof is being re-thatched? The pub is situated on the A556 at the Plumley crossroads.

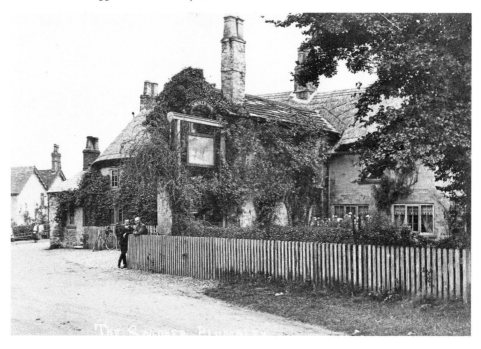

5

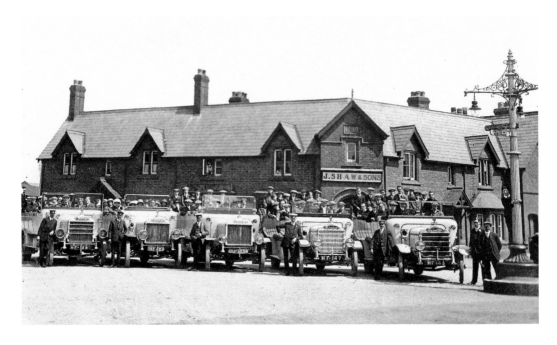

McDowells Store, 1910 to 1920

Here I have taken the liberty of linking three old photographs and a modern one. This shows the shop that stood on the corner of Canute Square, and the White Bear is still on the opposite corner. This shop would be taken over by Fred McDowell's father, as shown over the page. Lined up in front of the shop can be seen a number of Daimler charabancs leaving for a day trip to the seaside. The modern photograph is of the building that has taken its place and now houses a very prestigious car showroom.

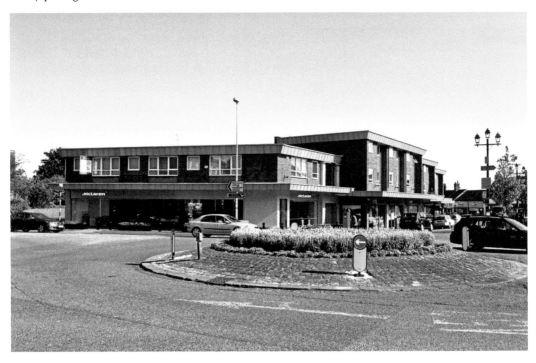

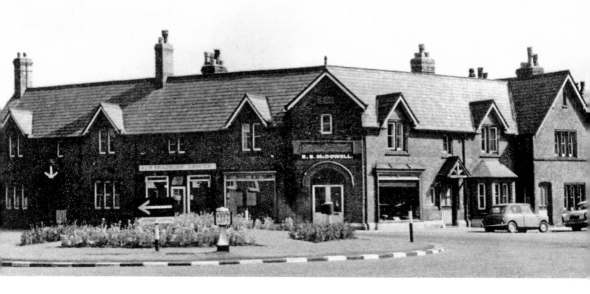

McDowell's Store, 1960s

Local historian Fred McDowell has provided many of the old photographs in the book, and this old photograph is of his father's store. In the coloured photograph his father can be seen in the doorway. Both photographs are from around the same period, although the coloured one is possibly slightly older.

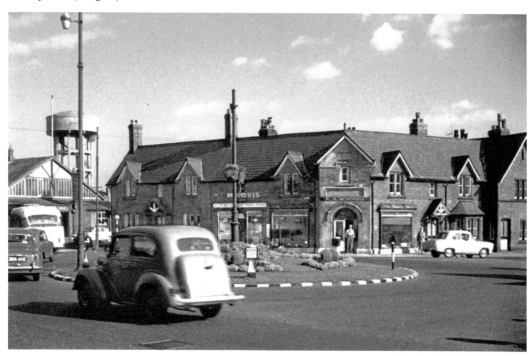

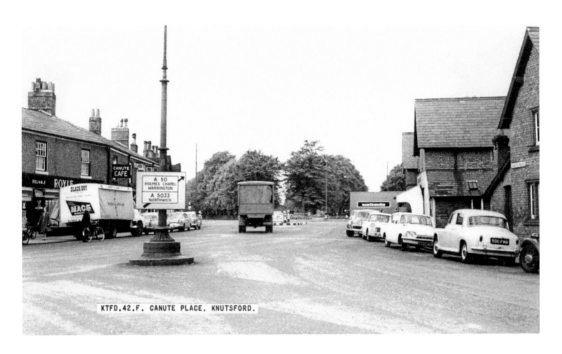

KTFD.42.F. CANUTE PLACE. KNUTSFORD.

Canute Square, 1960s

The road here has been altered and the road sign on the older photograph is on one of the iron lamp standards – one of five erected in 1844 by the Freeholders of Nether Knutsford. They remained unconnected and unlit by gas for many years, all but one being removed in the 1960s. A photograph of the remaining lamp can be seen on page 94. The period cars here illustrate how things change over time; the market was held here for many years.

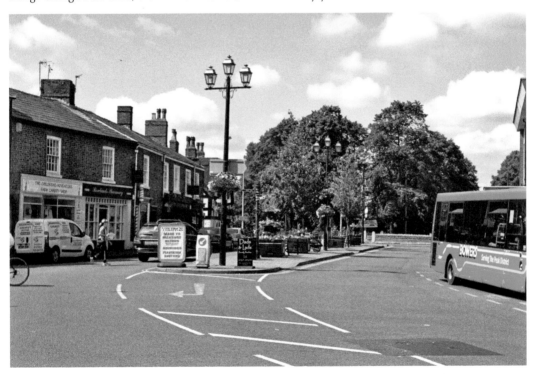

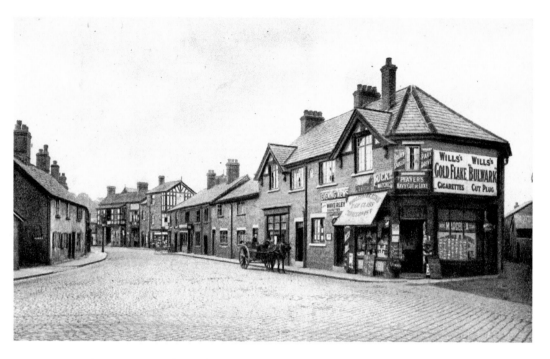

Canute Place Newsagent's, Early 1900s

Now looking in the opposite direction, towards Tatton Street, we see the newsagent's on the right. This store is still there, although the many period advertisements have gone. Quite a few of the buildings and cottages have resisted the developer in the intervening years.

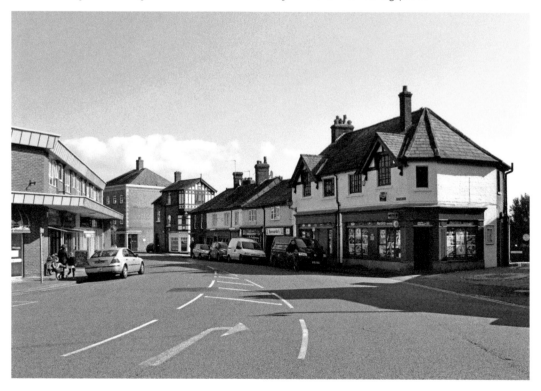

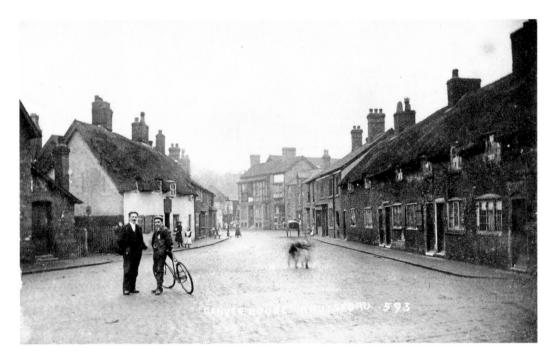

Canute Place, Late 1800s

Back even further now to before the newsagent's was built, and thatched cottages abound. The white cottage on the left was the Feathers Inn, which reverted to a cottage in 1910 and, as can be seen in the previous old photograph, it lost its thatched roof at around the same time. Pedal cycles have just arrived on the scene and the men observing the cameraman have acquired one. It was then known by its full title of 'bicycle' and when riding it you were 'bicycling'!

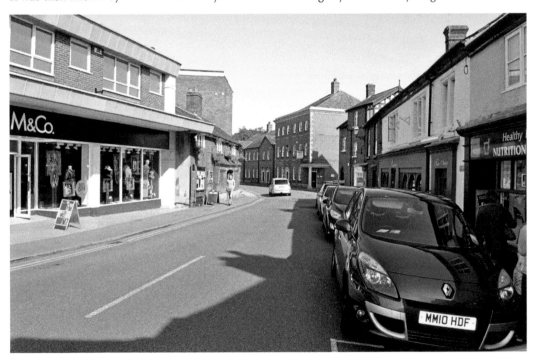

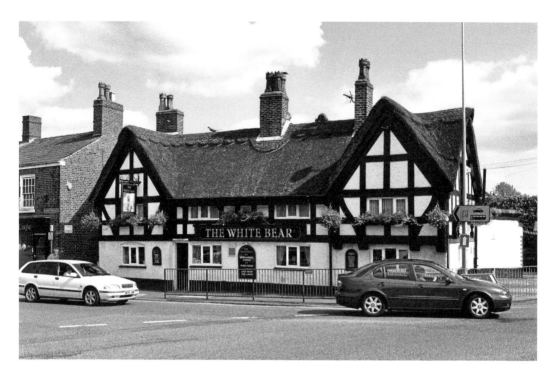

The White Bear, 1910

Here we have Knutsford's best-known landmark, the ancient White Bear public house on the corner of Canute Place. This seventeenth-century pub was the home of historian John Howard whose father was the landlord for fifty years and whose excellent autobiographical book (*More Lees than Cheshire Fleas/Tinker Tailor, Soldier, Restaurateur*) is filled with anecdotes about historical Knutsford and life in the White Bear as a child during the war years.

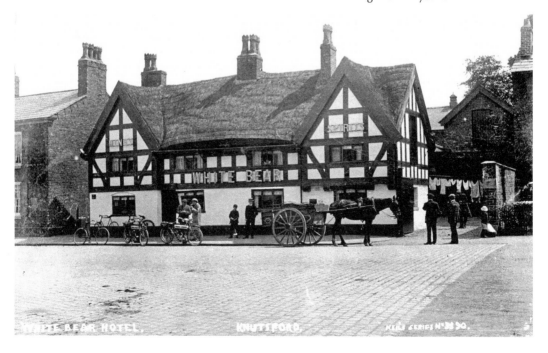

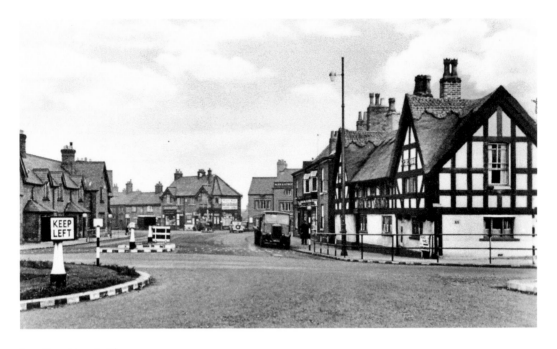

Junction Canute Place, 1950s

We now look into Canute Place in this old photograph, as an Albion lorry stands outside the White Bear. The newsagent's has retained at least one large advertisement. The new road, King Edward Road, opened in 1937 and is now part of the A50. It can be seen on the right running parallel with Princess Street and joining Toft Road further on.

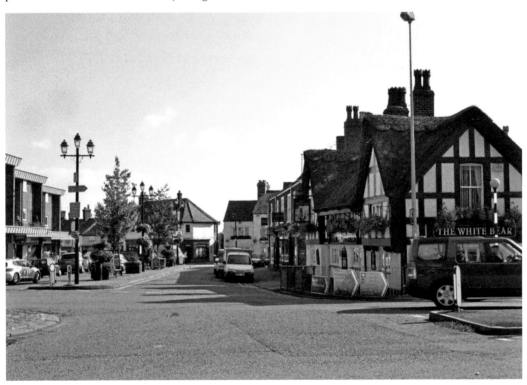

CLIFFORD J. BILLINGTON,

GROCER
AND
Provision Dealer,

Italian Warehouseman,

Fruiterer, &c.

TEA SPECIALIST.

Coffee roasted on the premises.

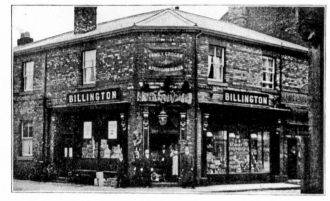

Canute Corner, Princess Street, Knutsford.

AGENT FOR THE NOTED
MARKET DRAYTON GINGERBREAD. PATENT MEDICINE VENDOR.

Billington's Shop, Early 1900s

Here we see the Clifford J. Billington's grocer's shop in Princess Street as depicted in an old advertisement. The building now houses a branch of the Santander bank and is situated next to the Red Cow public house.

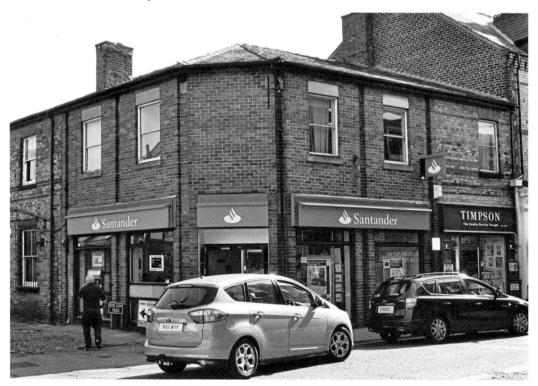

13

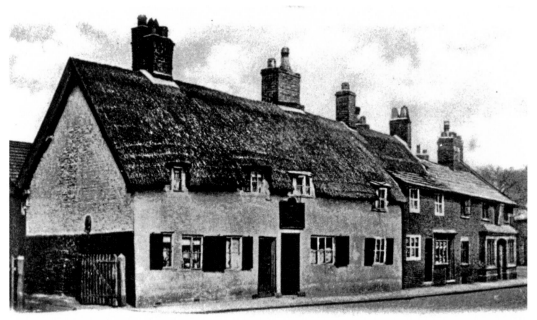

Old Cottages. *Knutsford.*

Old Cottages, Tatton Street, 1903

Back to where Tatton Street is joined by Canute Place and here is a better view of the old thatched cottages that in this photograph house the Feathers Inn. The Lord Eldon can be seen on the far right, sitting rather incongruously between modern buildings. This popular pub, believed to be the oldest in the town, is around 300 years old and has changed little over the intervening years; we cannot say the same for the old Feathers Inn!

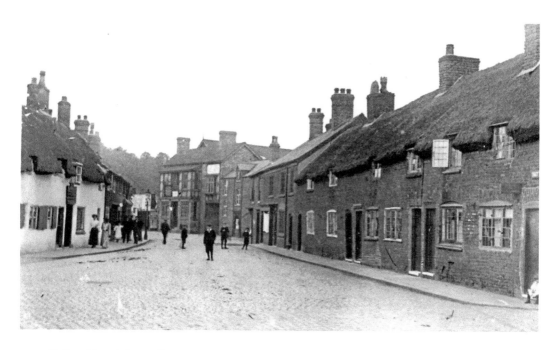

Tatton Street, Late 1800s

A last look at this part of the town. The old photograph is taken in the days when the photographer could spend half an hour in the middle of the road. This no longer applies, but then cameras are not so big! What must it have been like in those cottages? They look so cosy but perhaps those living there would not have agreed with that description.

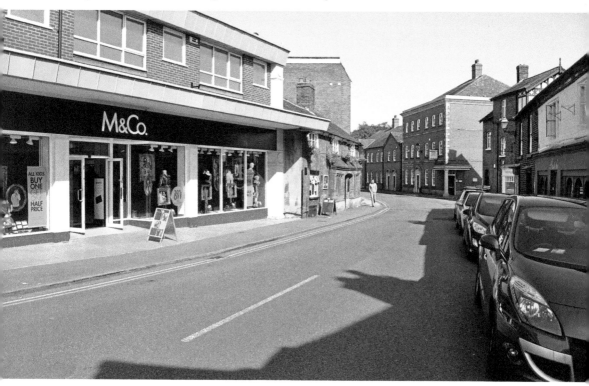

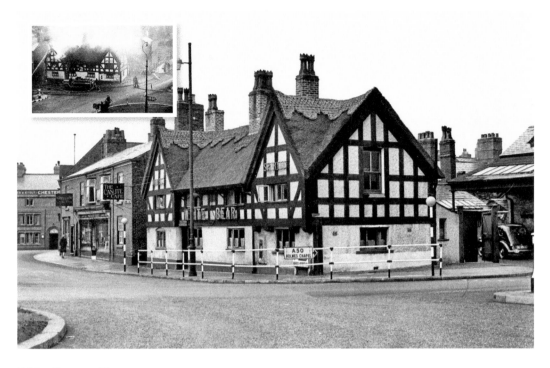

White Bear, 20 May 1950

A final view of the ancient White Bear. This pub was extensively altered on the front elevation in the late 1800s, but during the 1950s the attractive thatched roof caught fire – as can be seen in the inset. Fortunately, the option of replacing the roof with cheaper tiles was not taken and what we have is a beautiful black-and-white thatched building to welcome visitors to Knutsford. In olden times this pub was in Heathside.

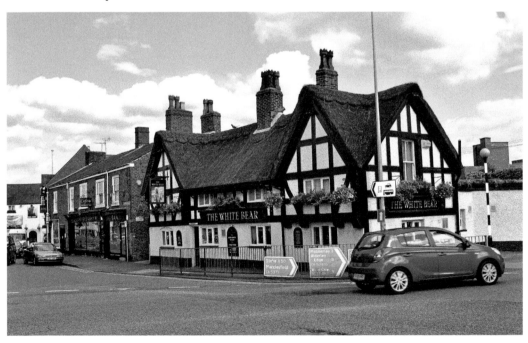

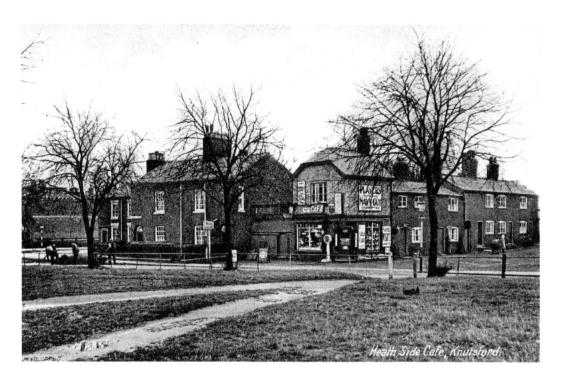

Heathside Café Gaskell Avenue, Undated

This old photograph is undated but is certainly post-1937, as King Edward Road can be seen at the end of the block. This was a café opposite the small Knutsford Heath, which is still there. However, the grassed area at the side – Cannon Square – has gone, together with the shop, to make way for the modern flats. A plaque on the front gives the date of construction as 2000.

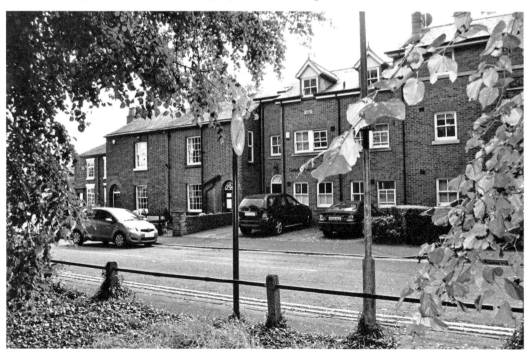

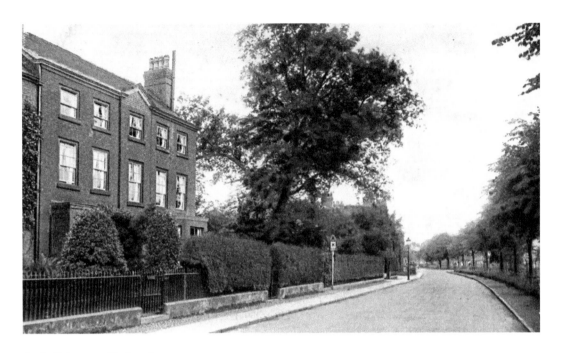

Gaskell Avenue, Undated

This view is down Gaskell Avenue, originally called Heathside as it runs along the side of the small heath as opposed to 'The Heath' – now better known as Knutsford Heath – which is far bigger and on the other side of Northwich Road. Mrs Gaskell's house can be seen on the left. As a tribute to this esteemed local author the road was renamed Gaskell Avenue after her death on 12 November 1865. Travel further along the road and you will find Heath House, which was once the home of Edward (Highwayman) Higgins, a short road with a lot of history.

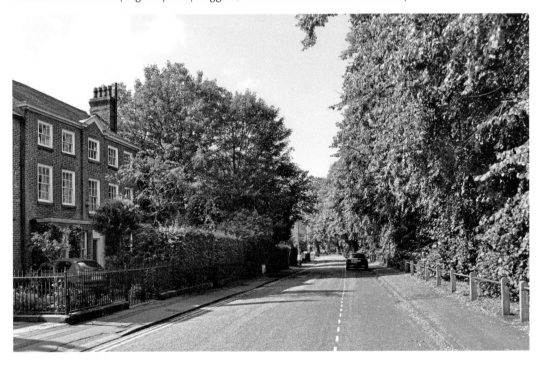

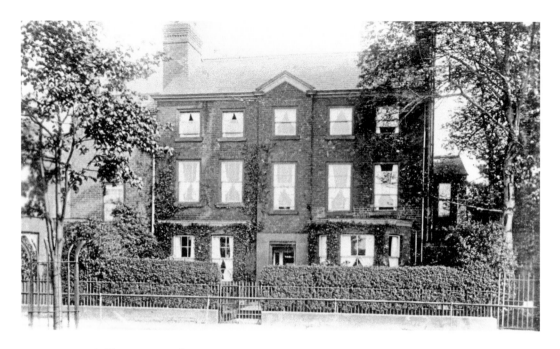

Mrs Gaskell's House, Early 1900s

Heathwaite House was once occupied by Elizabeth Cleghorn Gaskell, who was born in Chelsea. She lived here with her aunt, Hannah Lumb, from shortly after her birth (her mother died three months after giving birth) until the age of eleven when she went to boarding school in Stratford-upon-Avon. An accomplished and famous author, she loved Knutsford and depicted the town in her fictional novels – one example being *Cranford*. She was married in Knutsford and is buried with her husband in the graveyard at the nearby Brook Street chapel.

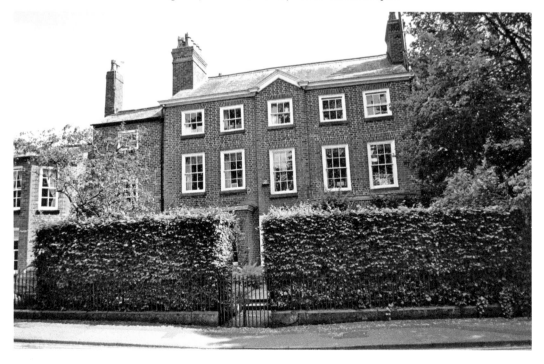

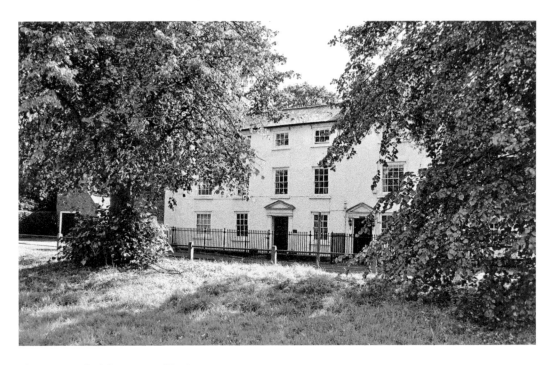

The Home of Highwayman Higgins, 1920

This large house on Gaskell Avenue was the home for many years of Edward Higgins or Highwayman Higgins. In 1754 he had been transported to America for housebreaking. He stole a large amount of money whilst there and returned in 1756. He bought this house, got married and had five children. By day he was a member of the gentry, but by night he was a burglar and highwayman. His wife and friends believed that he had property around the country that he had to collect rent on. He was caught in Carmarthen and hung there on the 7 November 1767.

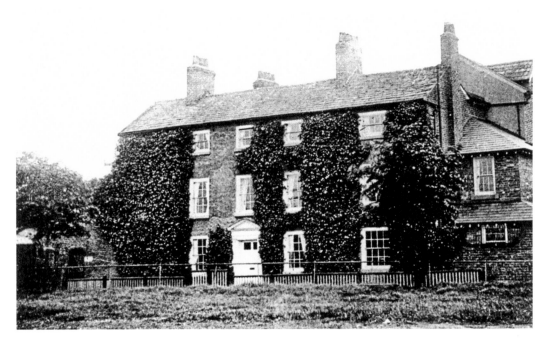

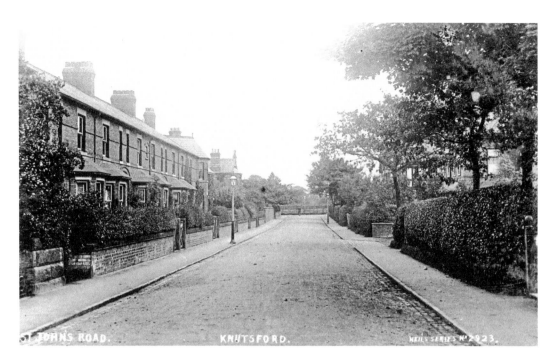

St Johns Road, Early 1900s

A look now at one of Knutsford's residential streets; this one near to the old Knutsford prison would have housed warders from there. The house with the arched porch, No. 31, was the Methodist chapel manse from 1930 to 1960, after which it was sold and the manse transferred to No. 12 in this road.

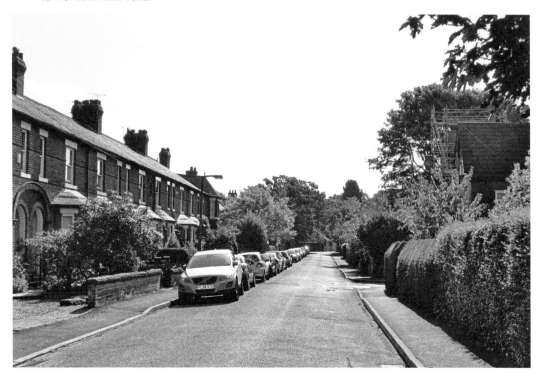

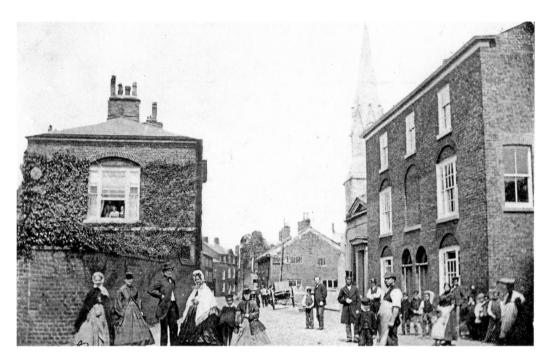

Princess Street, 1865
This is one of the oldest photographs in this book, looking into Princess Street from Toft Road in 1865. The ladies looking from the gable-end window on the left are the Misses Holland, cousins of Elizabeth Gaskell. The man and boy in the centre of the road are Tom Lee and his son Robert. Photography was in its infancy, and the attention given to the photographer who spends a long time in the road taking his photograph with heavy and cumbersome equipment.

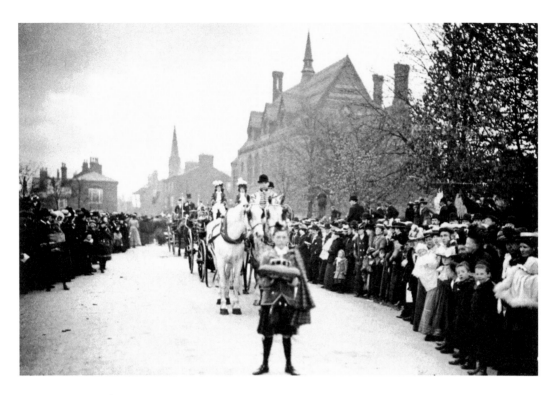

May Queen's Crown, 1902

Here we look down Toft road towards Princess Street as the Royal May Queen's crown precedes her past the town hall. It is carried by a page in kilt and full Scottish dress. Again, the procession would have been delayed for the photographer to carry out his duties. King Edward Road would later join Toft Road here, having cut through the gardens of the houses at the rear of Princess Street.

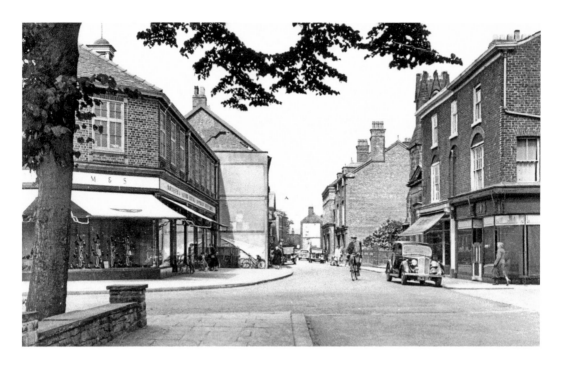

Princess Street, 1950s

A later picture showing Toft Road and Princess Street. The card is marked 1940–49, but on closer inspection I see a car in the distance that originated in the 1950s. Combined with that, the church spire, which suffered damage in a gale in June 1914, was found to be dangerous and was demolished in 1949, and in the old photograph there are signs that the spire has been removed quite recently.

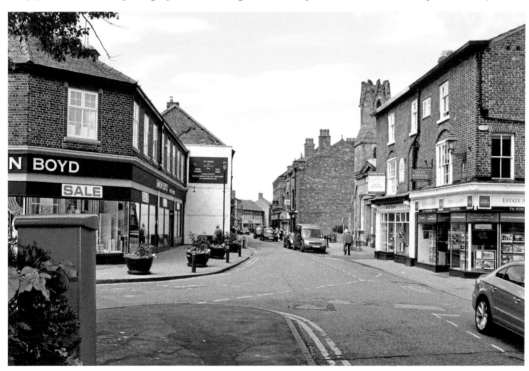

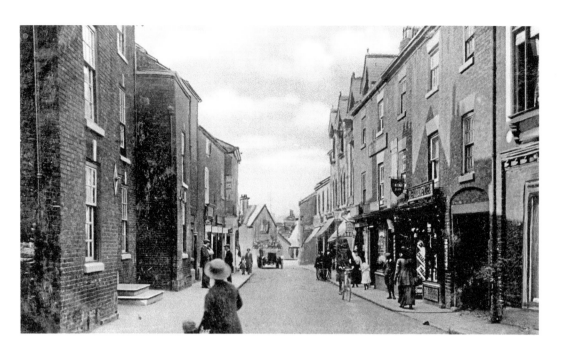

Princess Street, 1915

Further into Princess Street now looking out into Tatton Street/Canute Square as a bus turns towards the camera, the long-standing business of James Davey, pork butcher, can be seen on the right. When you look at the modern photograph, consider that, before King Edward Road was constructed, this narrow street was the main road through the town! The First World War had only been ongoing for a year, but already the town had been affected by the losses recorded.

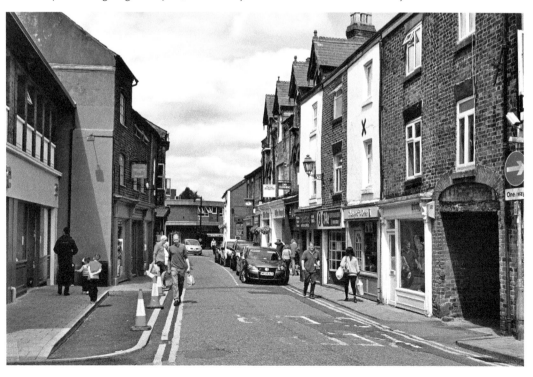

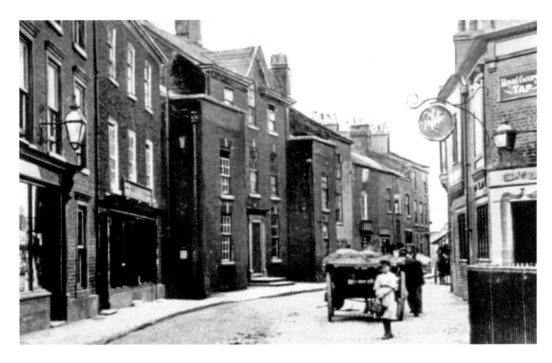

Princess Street, 1890–99

Taking a step back in both location and time, we see the Royal George Tap. These premises were part of the Royal George Hotel in King Street. The hotel was one of Knutsford's most prestigious, and whilst the gentry would enjoy the facilities in the main hotel, their staff in the form of butlers, carriage drivers and the like would enjoy the rougher facilities in the Tap. Now a very exclusive bar called The Lounge, little in the way of architecture has changed, on that side of the road anyway.

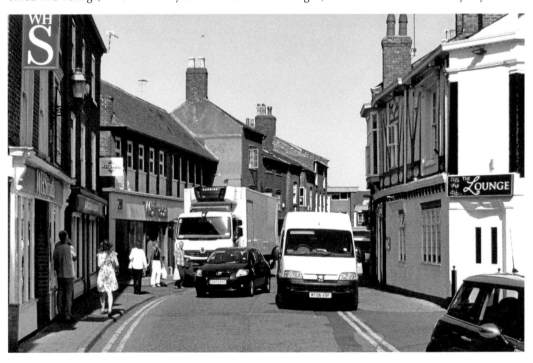

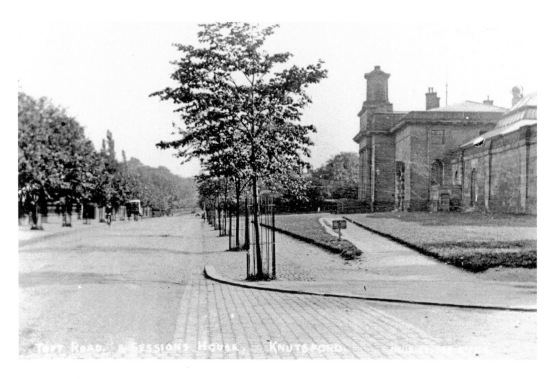

Toft Road, 1920s

King Edward Road has not yet been constructed and Toft Road is joined to Princess Street as we look towards Holmes Chapel. The large building on the right was then the Session House that fronted Knutsford Prison, built in 1818. In later years it became, and remains, Knutsford Crown Court. Trees and shrubs have now grown and conceal the end of the court building.

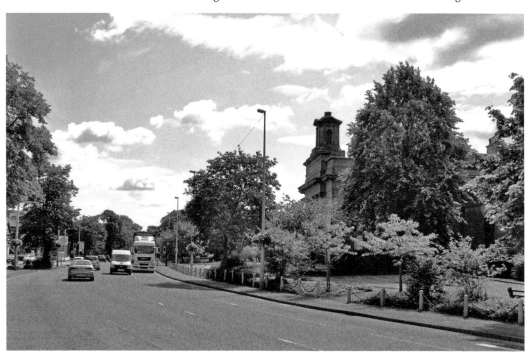

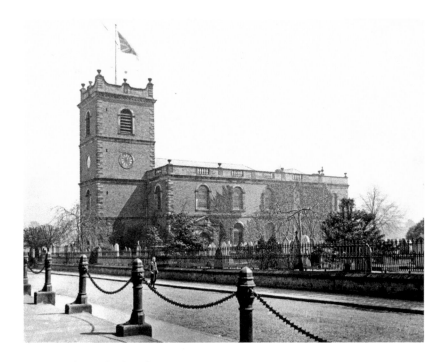

Knutsford Parish Church, 1902

Standing at the top of Church Hill we see the parish church of St John the Baptist. Until the eighteenth century this was a chapel of ease in the parish of St Mary's at Rostherne. This building was built between 1741 and 1744 and became a parish in its own right. The parish register can be traced back to 1581. As can be seen, it's another case of the lovely ornamental railings going for the war effort.

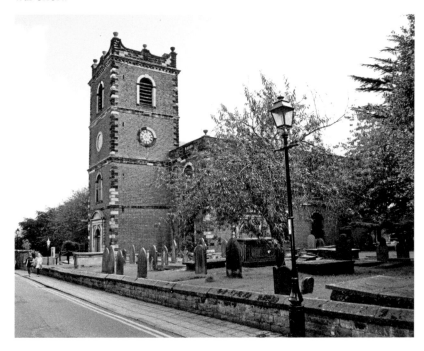

Hollingford House, Undated

With Knutsford being the setting for Elizabeth Gaskell's books, it goes without saying that a lot of the older properties will have been used. This house on the edge of the graveyard is now a shop premises but it was used by Mrs Gaskell in her novel *Wives and Daughters*, depicted as the home of Dr Gibson, father of Molly, in the small town of Hollingford. This was Mrs Gaskell's last novel.

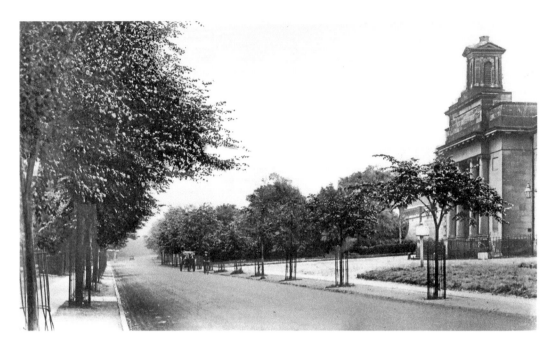

Toft Road, Early 1900s

A last look along Toft Road with a clearer view of the Sessions House, all of the railings are still intact and a heavy cart is towed towards the camera. There is also an early car heading to Holmes Chapel and a man on a bicycle passing the court. The photograph is from an early postcard that has been hand tinted.

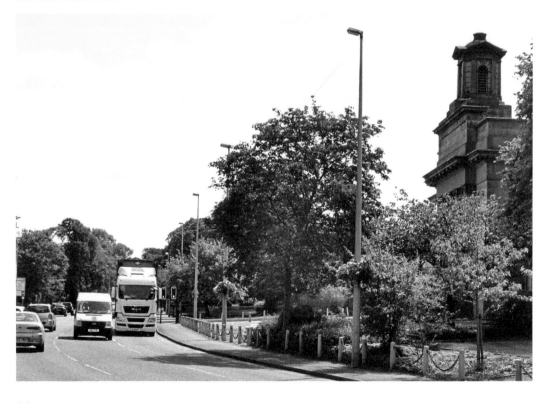

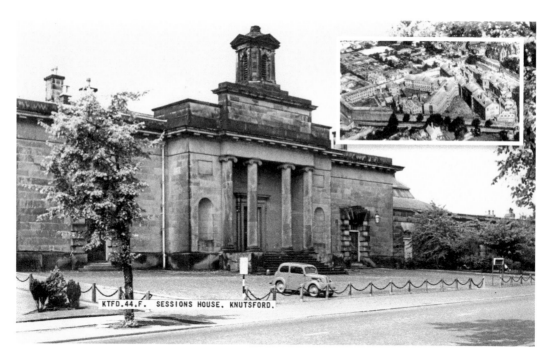

KTFD.44.F. SESSIONS HOUSE. KNUTSFORD.

Sessions House, 1950s to 1960s

We now get a clear view of Knutsford Crown Court. This was originally a large prison with accommodation for up to 700 prisoners and this inset gives an indication of the size. It was built when Chester prison reached capacity in the lawless days of the early 1800s. It was opened in around 1820 and remained so for 100 years. During this time it held, amongst many others, Chartist prisoners and IRA men from the 1916 uprising. Finally, it became a military detention centre and a TOC H training school.

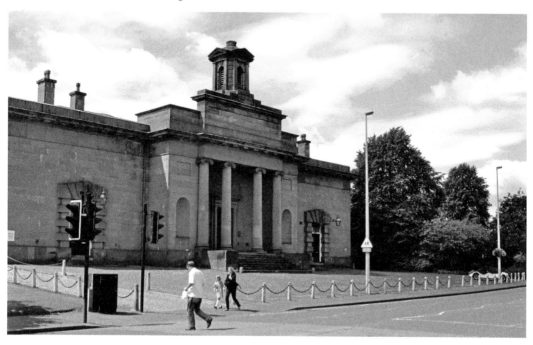

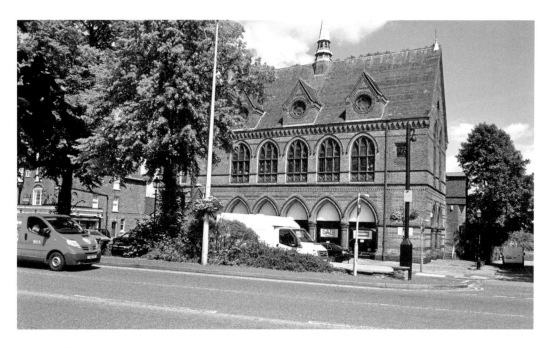

Town Hall, Early 1900s

This beautiful building was built in 1872 by Lord Egerton of Tatton and designed by Alfred Waterhouse who was also responsible for, amongst other buildings, Manchester Town Hall and the Natural History Museum in Kensington. Originally it had a market hall on the ground floor and at this time the archways were open in typical market architecture. There was a concert hall on the second floor with seating for 400 persons; the arches have been filled in.

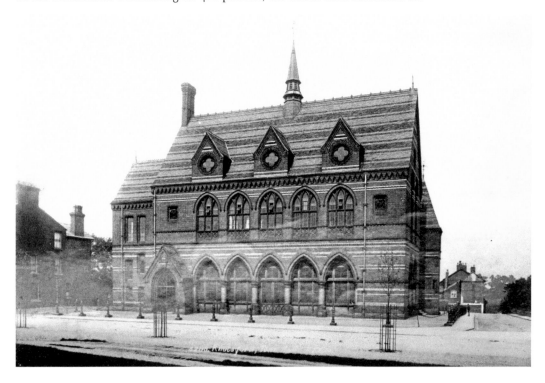

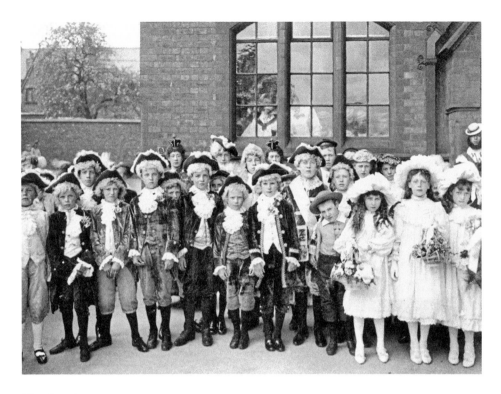

May Day Scene, 1902

A few photographs now of the Knutsford Royal May Day as the children taking part prepare for the procession. Here they stand in front of the Egerton School. This school was, like the town hall, built by Lord Egerton of Tatton and opened in 1893 as a Church of England school for boys and girls. The children are dressed in their Regency attire and are standing in the playground of the school whilst others peer from the classroom window.

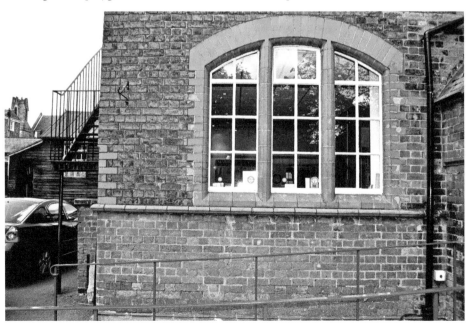

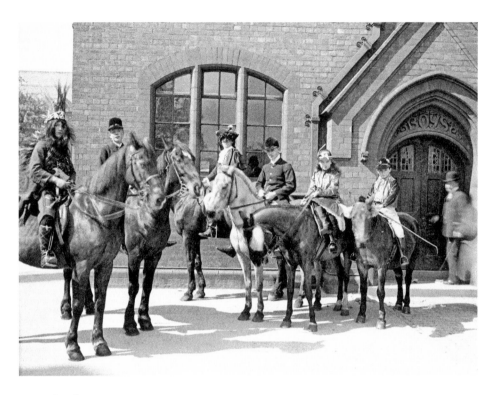

Preparing for May Day, 1902

Older children are now mounted and ready for the off. In the background can be seen the boys' entrance, clearly marked above the door, as was the girls' entrance at the other end of the school. The school was closed in 1973 and the Egerton Primary school is now situated in Bexton Avenue in a modern building. I was unable to get an accurate modern shot here because of the notice board.

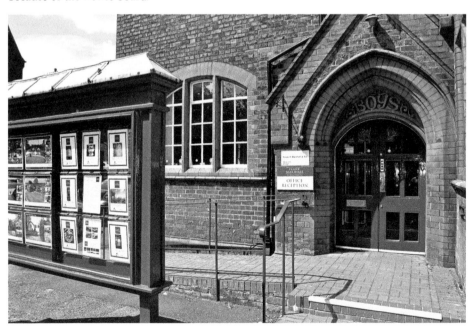

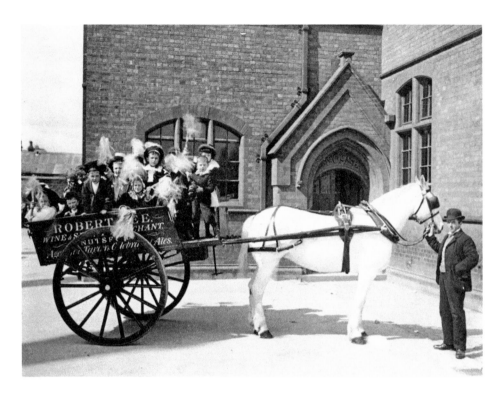

May Day, 1902

A last look at the preparations for the Royal Knutsford May Day, as the children here sit in a cart pulled by a pony. The name on the side is Robert Lee of Princess Street. His story is told in the excellent book on Knutsford by John Howard as mentioned in the Introduction. The Egerton school went on to become the auction rooms of the well-known Knutsford Auctioneers Frank R. Marshall.

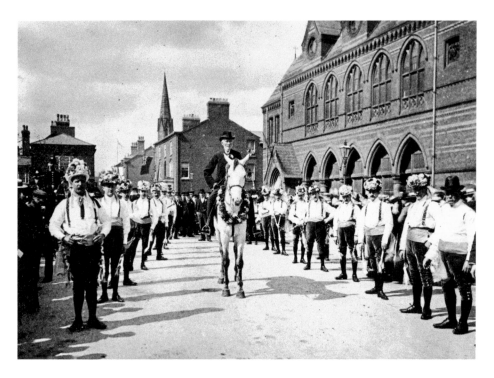

Morris Dancers, 1902

These Morris Dancers were taking part in the May Day celebrations and the interest in this ancient activity was renewed when Knutsford invited teams to take part. The steeple on the Princess Street church can clearly be seen here. The man on the white horse will have been the Parade Marshall, a duty undertaken by Fred Lee for twenty years.

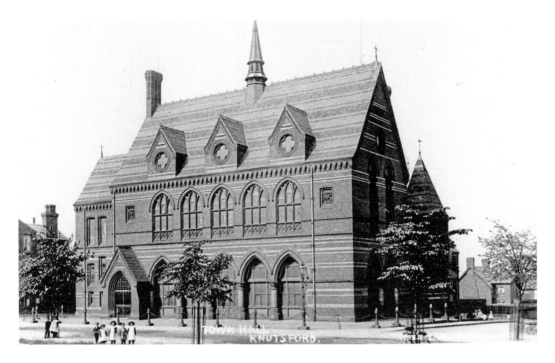

Town Hall, 1920s to 1930s

Here we have a last look at this impressive building and a mention of an important incident that occurred here in the war years. General Patton, then based at Peover Hall, was invited to open it as a Welcome Club for soldiers. He was not due speak but was invited to, and made an off-the-cuff speech, which was misquoted around the world. It was said that he snubbed the Russians. This was known as the 'Knutsford Incident' and damaged his career in the short term.

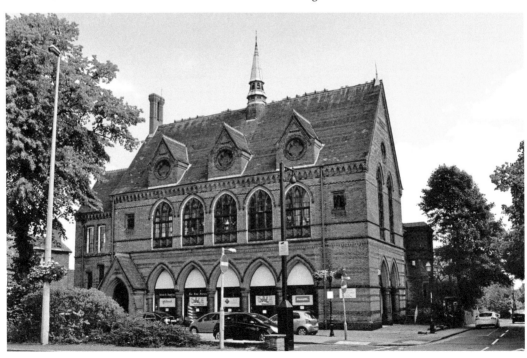

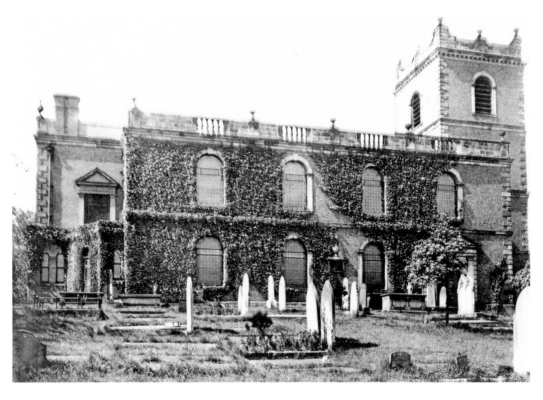

Parish Church from Rear, Undated

Here we have the rear of Knutsford parish church and can see that part of the graveyard has been grassed over with a community hall built on the side. The ivy that once covered the church has gone, revealing clean lines and ornamentation.

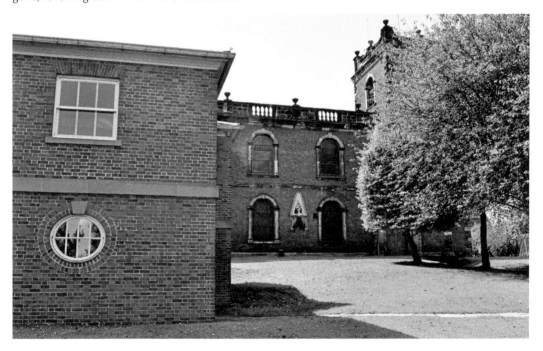

Toft Road, June 1906

This old photograph shows the junction of Toft Road and Adams Hill looking back towards the town hall, the spire of Knutsford Methodist church, and the parish church. This is another photograph hand tinted in the early days of the last century. A car and motorcycle are on the road and this is a good example of the beginning of the change in road traffic from horse drawn to the internal combustion engine.

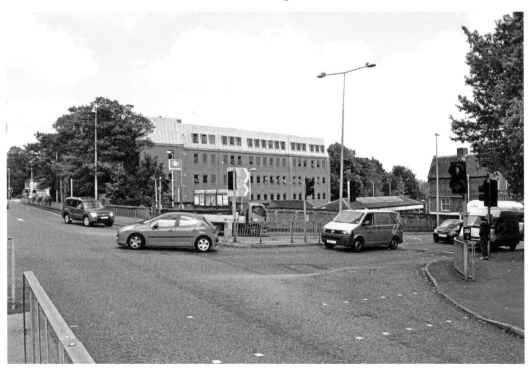

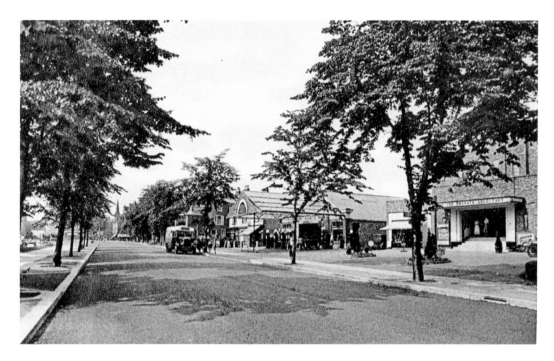

Toft Road, 1935

This photograph looks back along Toft Road towards the site of King Edward Road, which was constructed in 1937. Knutsford cinema is shown on the right in both shots, and showing at the time is the film *The Private Secretary*, which was released in September 1935 and dates this photograph to around that time. In the 2011 photograph, *The Inbetweeners Movie* is showing.

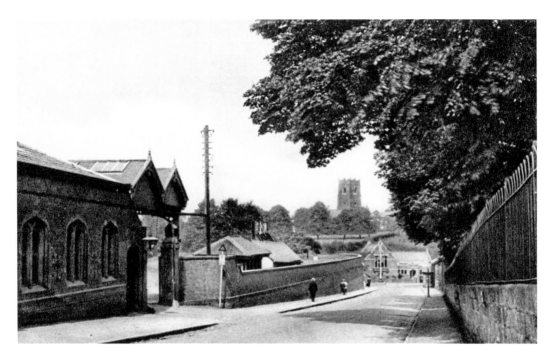

Adams Hill, 1926

Back now to Adams Hill and we see the vehicular access to Knutsford railway station on the left. There have been some changes over the intervening years, and amongst these is the removal of the twin-hipped roof and internal door, giving more room between the gate posts. The tower of St Cross church in Mobberley Road can be seen above the library.

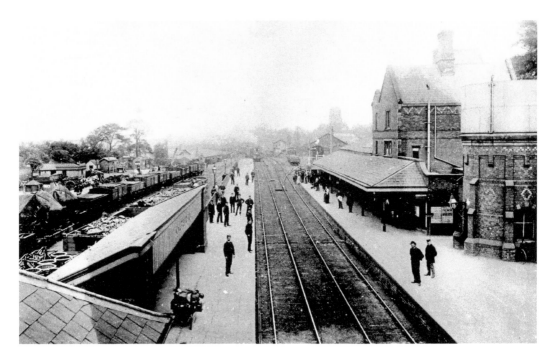

Railway Line, 1912

Here we look over the bridge parapet from Toft Road down onto Knutsford railway station. This line was part of the CLC – Cheshire Lines Committee – and was opened on 12 May 1862 with services from Knutsford to Altrincham. In 1863 the line was extended to Northwich in the opposite direction. Note the quite extensive goods yards on both sides of the platforms and the small engine shed at the end.

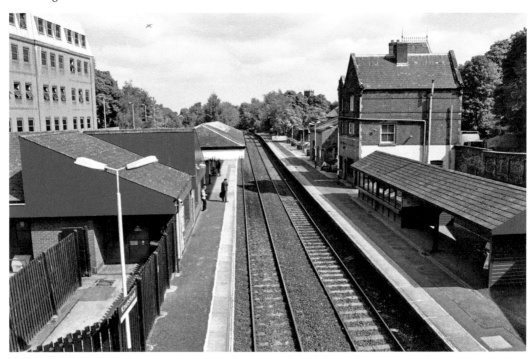

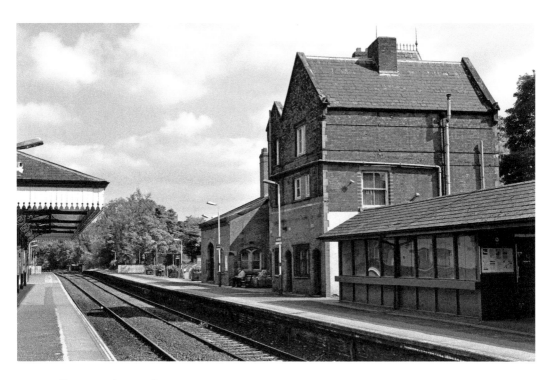

Railway Station, Early 1900s

Down at platform level on the Manchester-bound side we can see the differences that have occurred over the years. The twin-hipped roof from Adams Hill can be seen at the far end of the canopy on the opposite platform; canopy, roof and water tower have now gone together with the period adverts for such delicacies as Kilverts lard, Camp coffee and Bass beer.

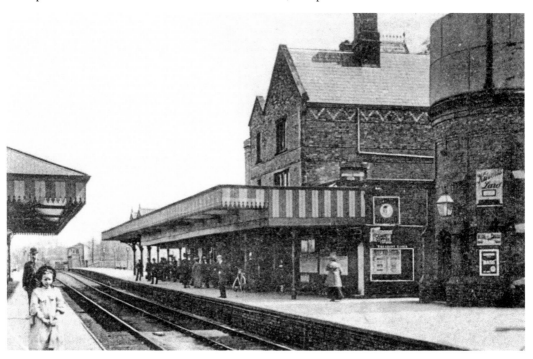

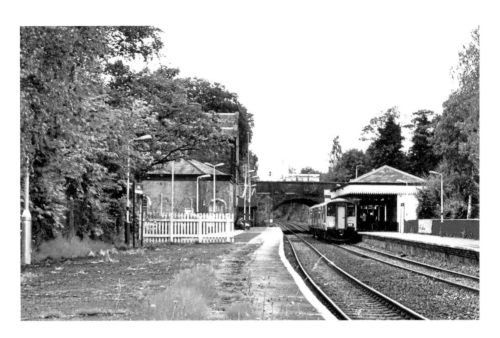

Railway Station Staff, 1912

Here we see the station staff at this small town station. I would estimate that the current staff would fit comfortably on the bench beside them. In those days labour was cheap and the stations were busy. I make twenty-four members of staff, from length men with their track equipment to the stationmaster in his fancy uniform. The engine in the old photograph is an unusual 2.2.2 locomotive designed for the CLC by Charles Sacre.

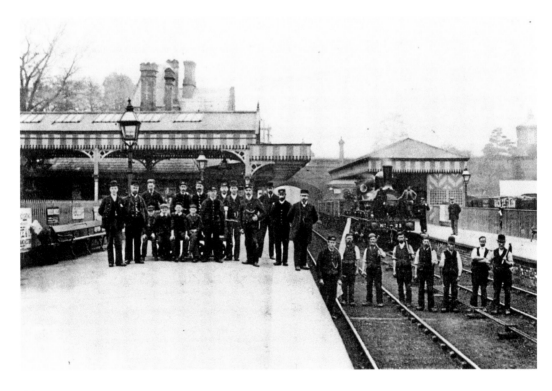

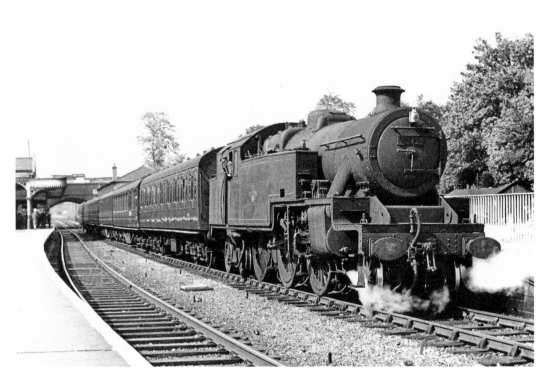

Steam Train, 1950s

Now we look from the Chester-bound platform as a train for Manchester leaves the station. In this case the engine is a Stanier 2-6-4T locomotive, introduced in 1935 for such work as this Chester–Manchester train. The modern depiction is a far more interesting Diesel Multiple Unit!

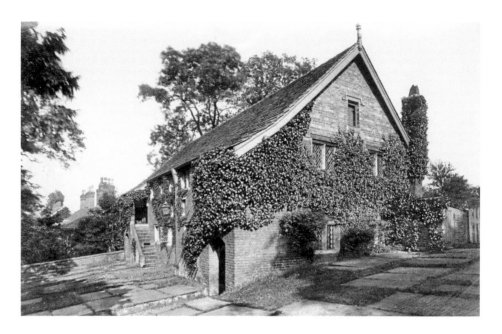

Unitarian Chapel, Undated

This chapel in Brook Street was built shortly after 1689. Prior to this date the laws of the land discriminated against so-called dissenters who followed religions other than the Church of England, such as Baptists and – as in this case – Unitarians (but not Catholics). The law was changed as a result of the Act of Toleration in 1689, which gave permission for the faithful to worship in their own chapels and churches. Elizabeth Gaskell and her family worshipped here and her grave is in the churchyard.

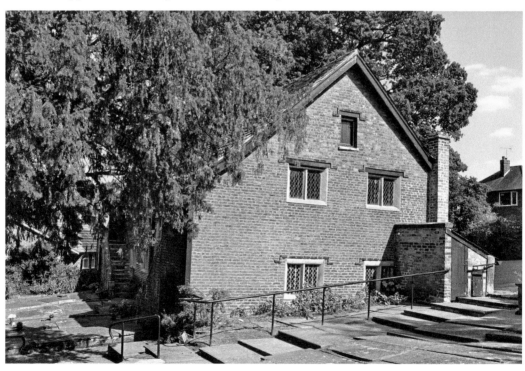

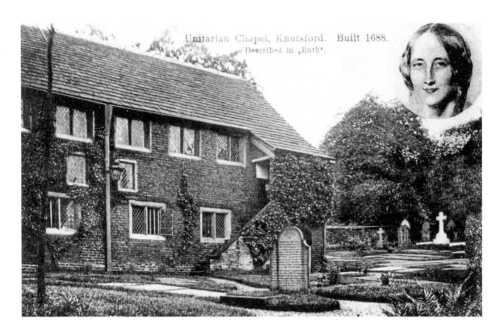

Unitarian Chapel, Undated

Here we have another view of this pretty chapel and the old photograph contains a picture of Elizabeth Gaskell, whose grave is marked by the small cross in the old photograph and can also be seen in the new. The date is given as 1688, which unless the chapel was built illegally is incorrect! From 1827 to 1872, Henry Green was the minister and in 1857 he wrote *Knutsford: its Traditions and History with Reminiscences, Anecdotes and Notices of the Neighbourhood.* This was reprinted in 2009.

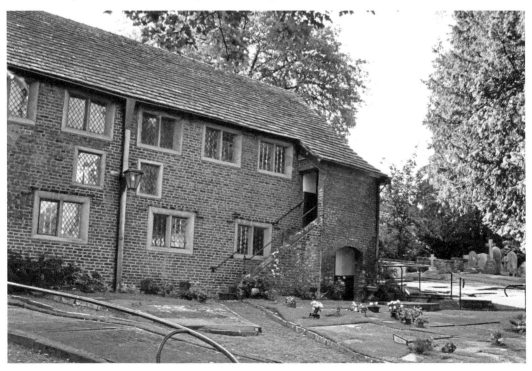

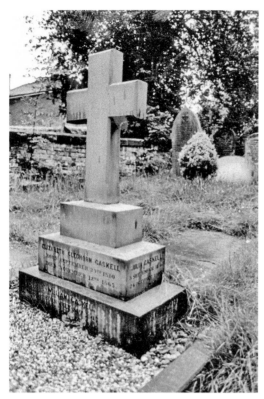

Elizabeth Gaskell's Grave, Undated
The actual grave of the popular Knutsford author, who died aged fifty-five years of age. Born in Chelsea, she grew up in Knutsford but moved to 42 Plymouth Grove, Manchester, (now No. 84) with her husband William, a Unitarian Minister, author and campaigner on behalf the poor. Her books were written there and visits were made by the likes of John Ruskin and Charlotte Brontë (whose biography she wrote). Elizabeth's husband, William, and their two unmarried daughters are buried with her.

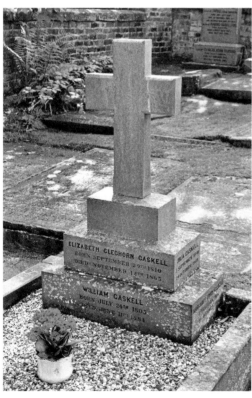

Knutsford Free Library, Early 1900s

Further down Adams Hill we come to Brook Street and the Free Library building, which was built in 1904 in Gothic style. It was funded by the Carnegie Trust and is now a children's nursery. In the old photograph the church of St Cross can be seen in the background.

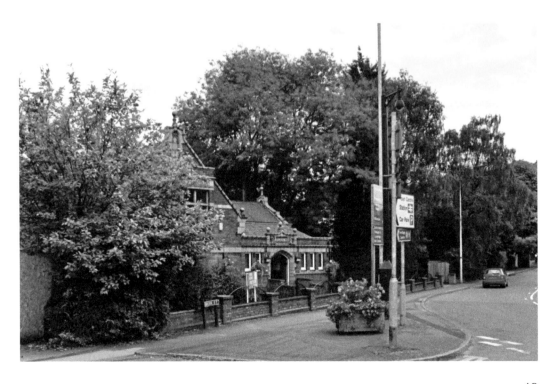

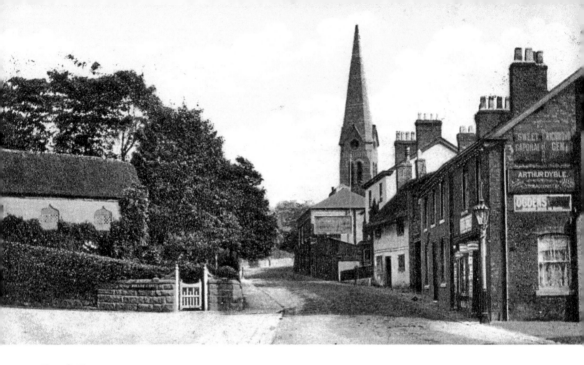

Brook Street, 1902

Continuing along Brook Street we come to the junction with Hollow Lane on the left. This road is taking us out of town towards Chelford. The tall, white building on the right has a plaque on the front giving its date as 1737, but apparently this only refers to the front elevation.

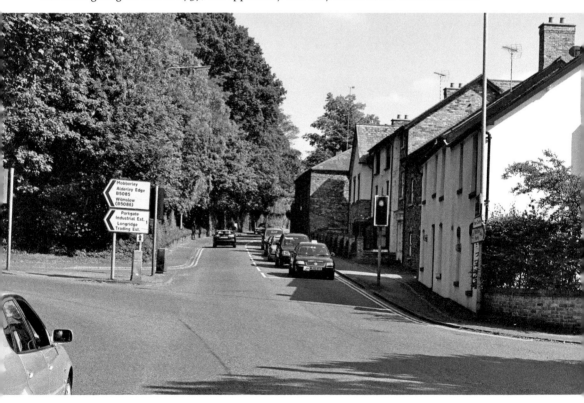

Brook Street, Early 1900s

Another view, similar to the last, but giving a clearer view of the ancient cottage on the junction. This was said to be the oldest building in Knutsford and was demolished in order, I assume, to widen the road. A beam from the cottage is marked 1411 and has been preserved in the new library. This date is disputed as being inaccurate in certain quarters and it is believed to date from 1711.

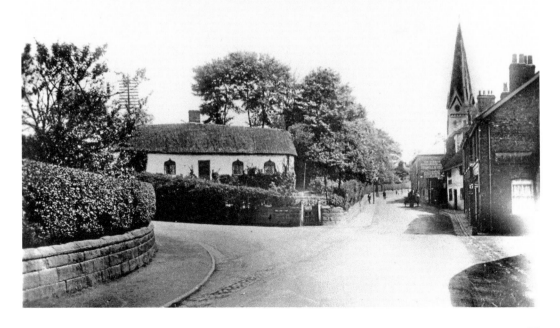

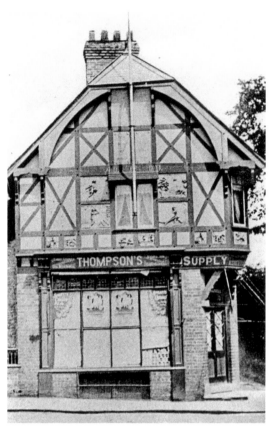

Thompson's Store, Undated

This highly decorated store stands at the junction with Mobberley Road. 1881 is engraved on one of the black beams and the wording, which has been renovated, reads 'Think of ease but work on No gains without pains'. Underneath the windows it says, 'Great business must be wrought today our mission is to serve, yours to quickly buy and we'll do our part full well – if you'l [sic] only let us try.'

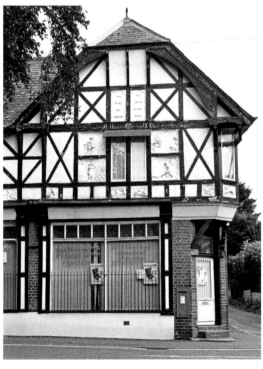

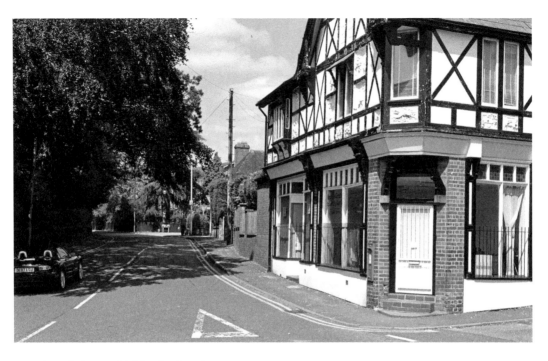

Brook Street, Mobberley Road, 1900 to 1909

A final look at this pretty shop, which now serves as a laundry and ironing service. In the old photograph we can see the cottages next door. These cottages can be seen beyond the later extension at the shop, they were in a poor state prior to being demolished and the area has been redeveloped. The shop went on to become the village store and post office; the post box can be seen in the modern photograph.

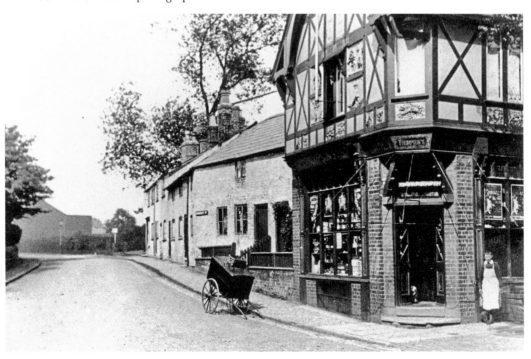

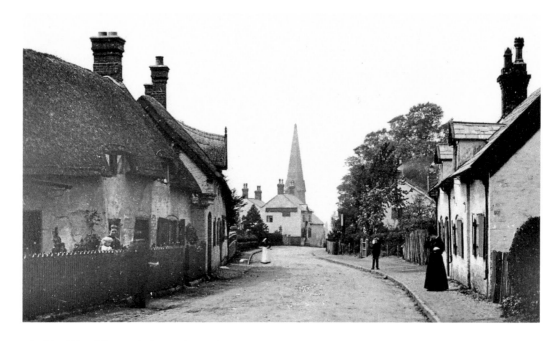

Chelford Road Towards Town, Late 1800s

We carry on now as the road changes its name from Brook Street to Chelford Road and we stop and look back towards the Legh Arms pub. The old picture here is filled with Victorian period charm; the cottages on the left were perhaps not quite so romantic if one had to live in them! They have now been swept away to make way for high-class, set-back dwelling houses. This is another case of the old photograph being taken from the centre of the road. Had I tried that I would have ended up as a bonnet mascot!

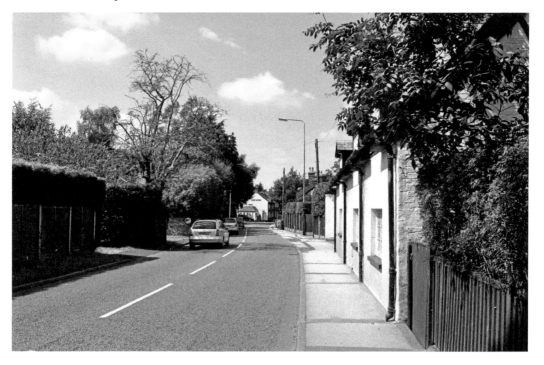

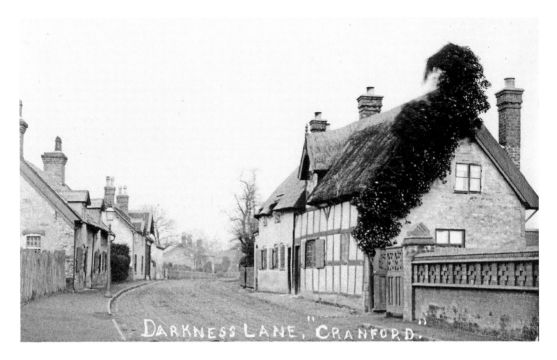

Chelford Road (Darkness Lane), Late 1800s

This road was depicted in Mrs Gaskell's novel *Cranford* as Darkness Lane. There have been some architectural changes here apart from the cottages on the right being demolished. The cottages on the left have gained another pitched roof window, but the ornamental wall on the right prior to the cottages has been retained.

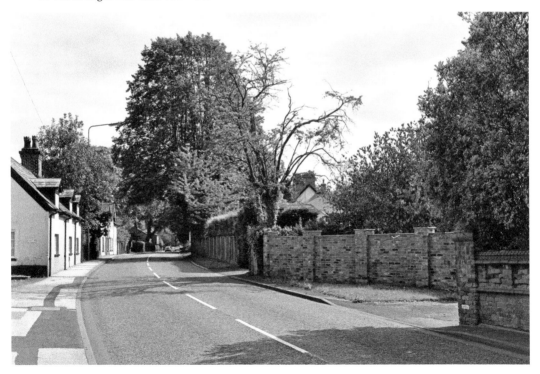

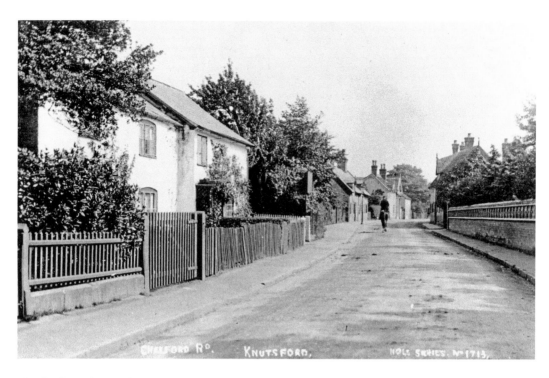

Chelford Road Out of Town, Early 1900s

This old photograph shows Chelford Road as it goes out of the town towards Chelford, similar to the last shot but incorporating a wider area. The cottage and wall in the last photograph can be seen on the right as the horse and rider meander down towards Knutsford.

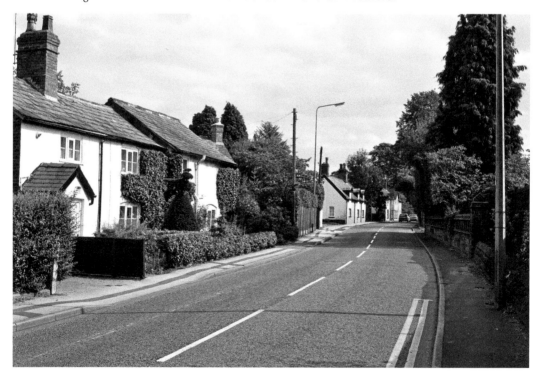

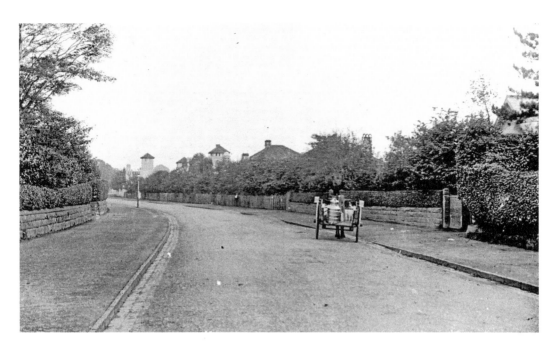

Legh Road, Date Unknown

Alongside the Legh Arms is this road, which must boast the most unique set of houses in Cheshire, if not the whole country. Richard Harding Watt was a glove maker in Manchester and made his fortune in this enterprise. He was not an architect but was well travelled and he chose Knutsford to live out his architectural fancies and bring them to life. Legh Road is where he built his own house, The Croft (now The Old Croft) in 1895. This was quite conventional but he then took his fantasies further!

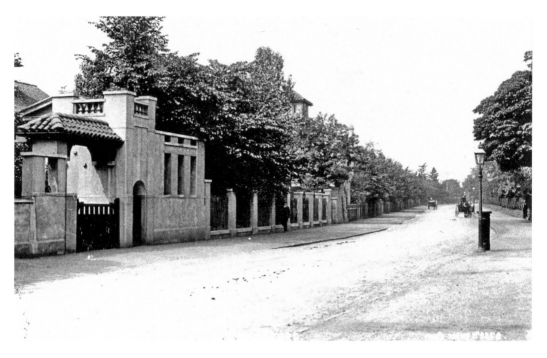

Legh Road, Early 1900s

Still in Legh Road we see the gatehouse of one of Watt's exotic creations. The houses are built in styles reminiscent of Italian villas – certainly not one would expect in an English country town – and he was subjected to some ridicule at the time. Now though, the houses are popular and the road quite exclusive. When Steven Spielberg made *Empire of the Sun* he used Legh Road for some scenes depicting old Shanghai. When we reach the town centre we will see further examples of his unique buildings.

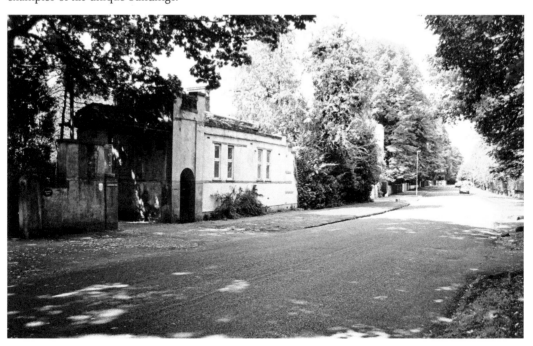

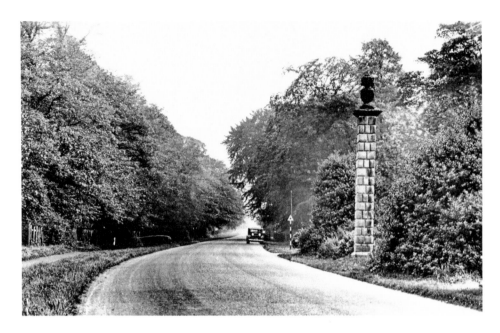

Obelisk, Undated

This large stone obelisk is situated on Chelford Road opposite Toft Cricket Club, and this is the approximate location of the original Norbury Booth's Hall, which was demolished in 1745. The obelisk was erected to commemorate the Legh family. Also note that in the modern shot there is a milkman's horse-drawn milk float.

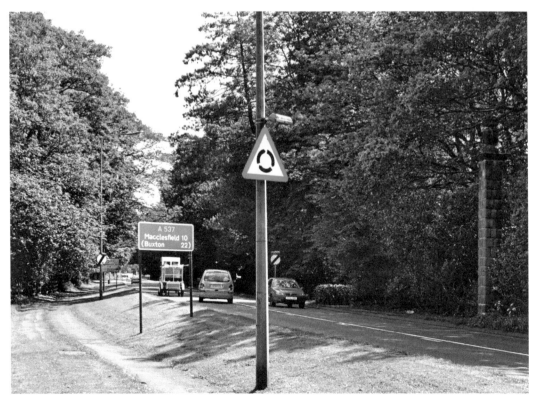

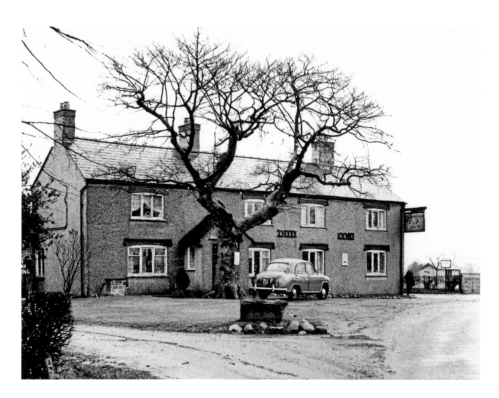

Ollerton, April 1955

Continuing out of Knutsford towards Chelford, we come to the village of Ollerton in which stands this pleasant country pub, the Dun Cow. In 1902 Stephen Parker was the landlord and was also a farmer. In 1825, *Pigot's Directory* describes the village, originally Owlerton, as unimportant with 300 residents but beautiful countryside and much cultivation. The pub is certainly more attractive now than it was in 1955 and it is very popular.

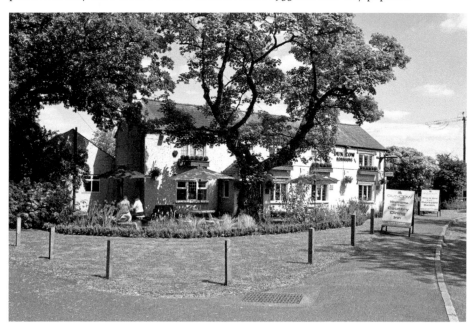

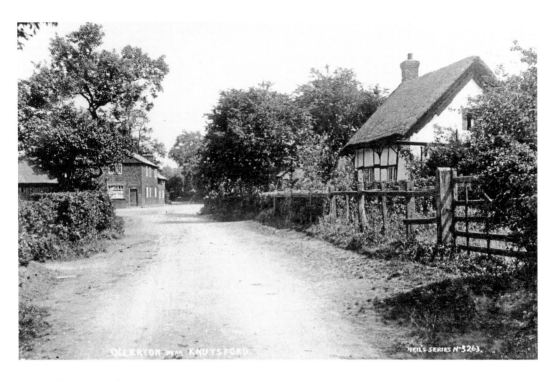

Ollerton, Early 1900s

Here we see two contrasting photographs taken in Ollerton with Marthall around the turn of the last century and the view across Chelford Road. The building in view past the crossroads is Ollerton post office, which closed in 2000. The last operator of the post office was Mrs Bailey who worked alone for a while after her husband passed away.

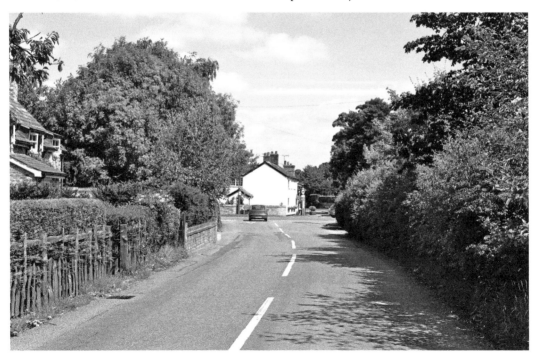

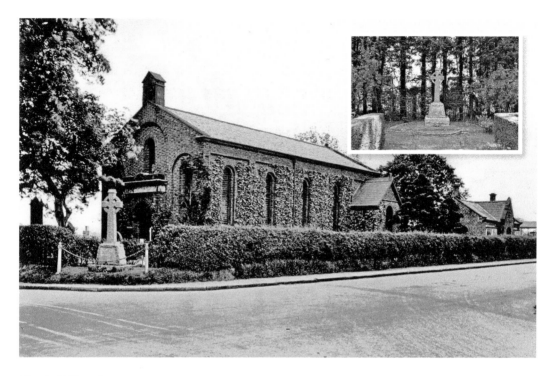

Marthall Church, 1920 to 1929

We now reach the extremity of our detour out of Knutsford, with Marthall church and its ultra-modern church hall at the rear. In the old photograph the war memorial is at the front but in the modern photograph is at the rear and can be seen in the inset. The church was provided by Lord Egerton of Tatton Hall and consecrated by the Bishop of Chester on 1 November 1839. The church hall is a more modern addition.

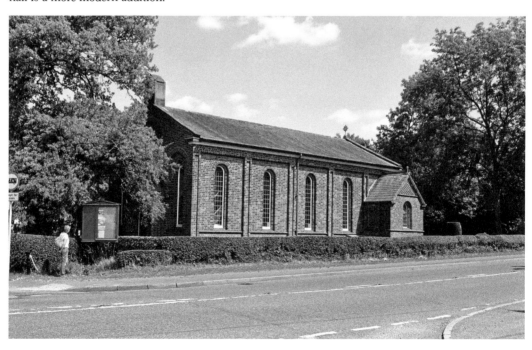

Congregational Church, 1900 to 1909

We now take a quick jaunt back to Knutsford and come to the Knutsford United Reformed church in Brook Street. This independent congregational church was built in 1866 with the manse and schoolroom, but was closed in the 1920s and demolished in 1938. The land is now an industrial concern and the house nearest the church can be seen in the modern photograph.

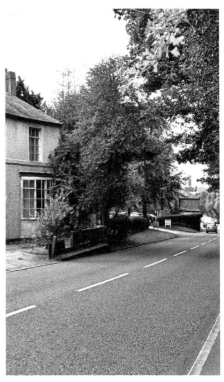

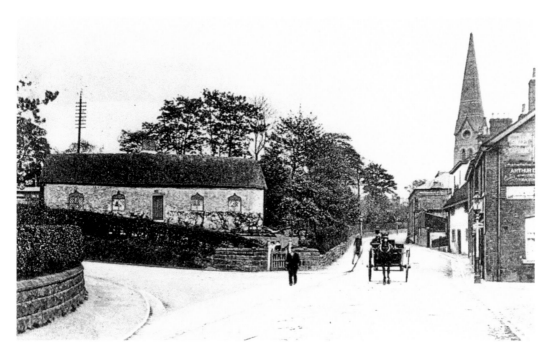

Brook Street, Hollow Lane, 1900 to 1909

We continue down Brook Street now as we pass towards the town. The road is now simply the route towards Chelford and Macclesfield but at the turn of the last century it was a popular residential area with far less traffic. The pony and trap is bringing its driver into town as a pedestrian crosses the road, which leads to Wilmslow and will soon link up with Mobberley Road.

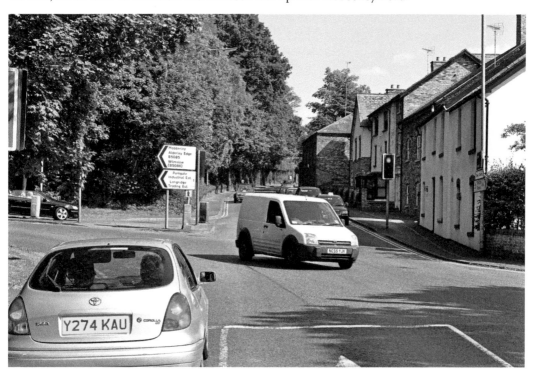

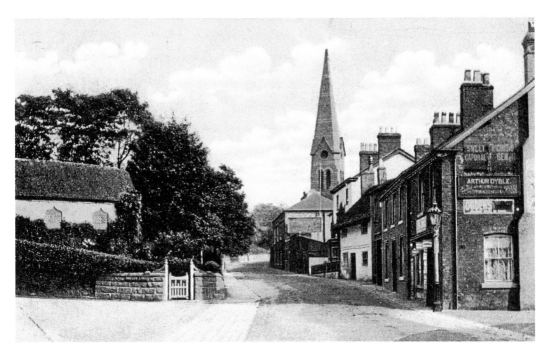

Brook Street, Early 1902
One last look at this well-photographed area, this time in colour. There is a clearer view of the period advertisements on the gable end of the shops, the first shop being a tobacconist with Arthur Dyble as the tenant. The long gone Sweet Caporal cigarettes are advertised there, together with the products of the Liverpool company Ogden's.

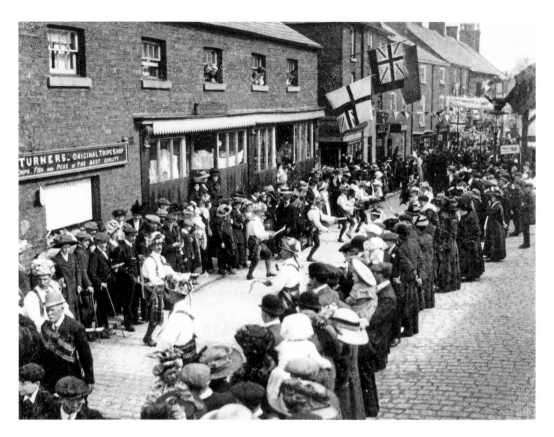

May Day, 1900 to 1910

We now turn into King Street and under the railway bridge, and in the old photograph a team of Morris Dancers are performing for the crowd. I should think that it is part of the May Day celebrations.

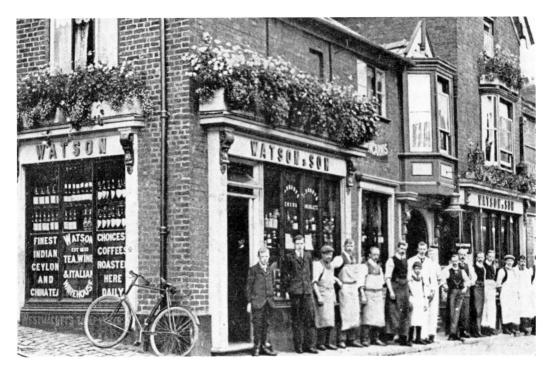

Watsons' Staff in 1913

This once well-known grocery store was an important service to the people of Knutsford. The business started as far back as 1852 and grew over the years to become one of the most successful in the town. Another store was opened in Minshull Street and several horse-drawn delivery wagons were used – later, motor lorries replaced them. The number of staff in the old photograph is evidence to this.

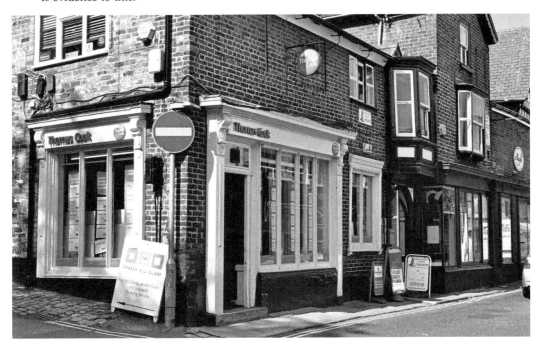

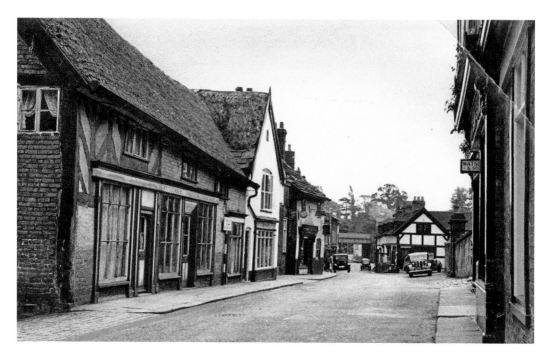

Tudor Cottages King Street 1940 to 1949

Turning round now and looking past Watson's store we look down towards the railway bridge around the period of the last war. Period cars and trucks are in the old photograph and the old black-and-white cottages can clearly be seen on the right, detailed in the next pair of photographs. Over the years the building on the left has lost its attractive thatched roof but other than that, not a lot has changed.

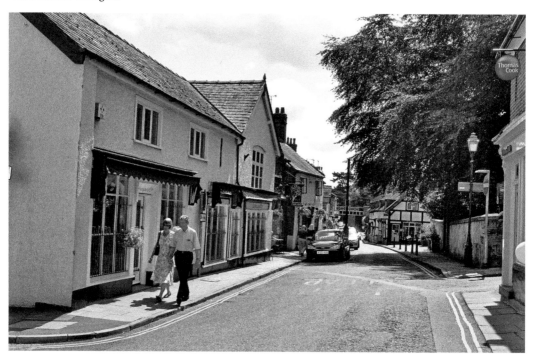

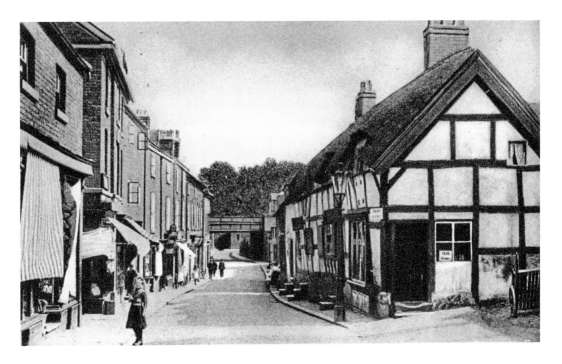

King Street, 1900 to 1910

We now take a closer look at these ancient cottages, which have been modernised but have retained their charm. What a pity that this treatment could not have been used elsewhere in place of the ugly buildings that have replaced charming cottages that only needed a little work, as this example clearly shows. The cottages were once thatched but suffered a fire in 1937 and slate was used in the refurbishment.

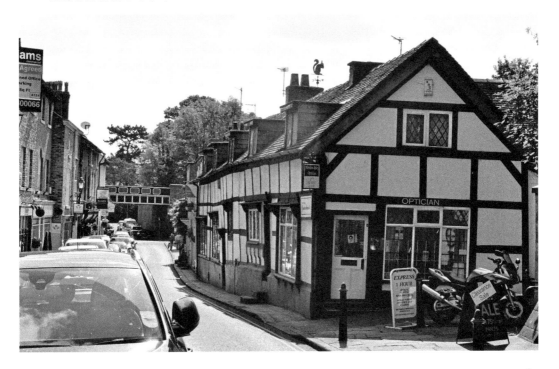

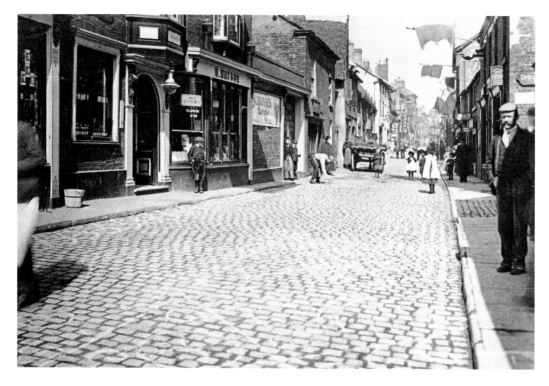

Sanding, May Day, 1902

Here we have the first old photograph of a practice that I believe is unique to Knutsford. The origins of many ancient traditions are misted in the fog of time and the same applies in this case. One theory that I think highly unlikely is that, when Canute forded the brook and allegedly gave the town its name, he shook the sand from his shoes ahead of a wedding party. We will go into it a bit more later, but here we see the practice in action prior to the 1902 May Day procession.

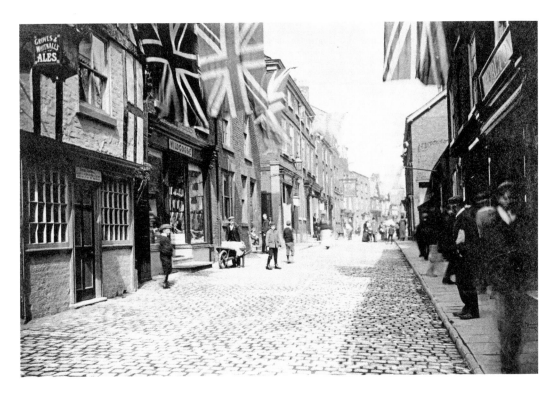

May Day Sanding, 1902

Here we have walked a little further along King Street to the Rose & Crown, where sand is still being used to decorate the sets. Another, more recent and realistic history of the practice is that during the 1700s wedding parties were serenaded by the bells of the Chapel of Ease in Lower Street. The bells became faulty and gave an unpleasant tone so the practice began of announcing the wedding by sweeping up outside the bride's house and sprinkling sand on the roadway.

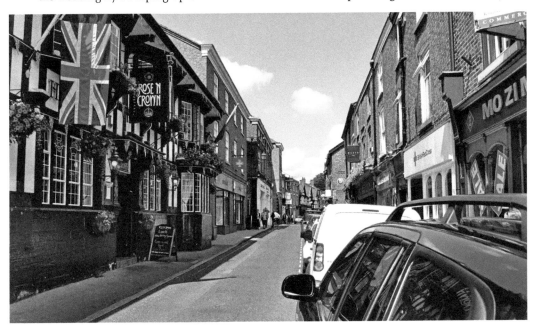

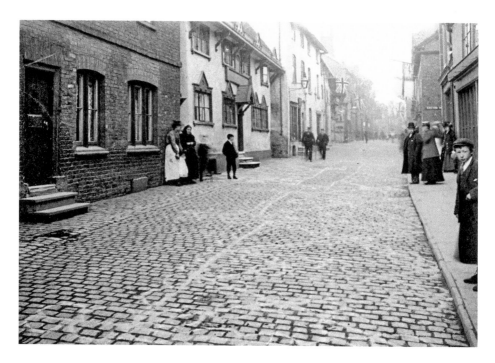

King Street Sanded, 1902

A final look at this strange practice, which still occurs today. Starting originally as a sprinkling outside the bride's door, it became popular to make fancy patterns with the soft sand, sometimes coloured, ahead of other ceremonies – mainly the May Day procession as here. The Cross Keys public house would soon be 'modernised', with the Hat and Feather pub next door, which was to be demolished to make way for the Gaskell Memorial Tower, seen in the modern photograph. The house on the left has been converted into a shop.

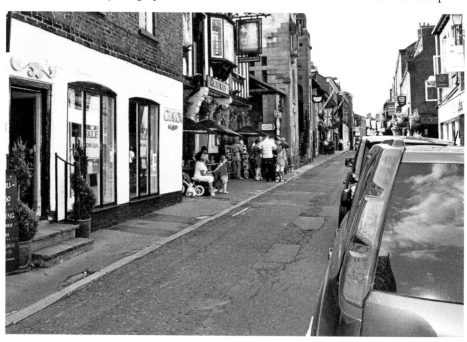

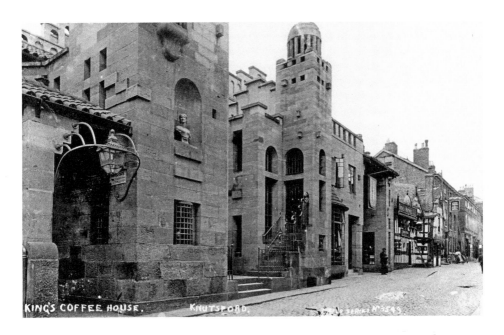

Kings Coffee House, 1900 to 1920

Continuing along King Street we reach the Gaskell Tower and Kings Coffee House – now the Belle Époque restaurant. Originally on this site was the Hat & Feather public house, purchased by the eponymous Richard Harding Watt, the man responsible for the Legh Road Italianate houses. Not welcomed by all as an addition to the town at the time of building, the Gaskell Memorial Tower was built in 'Eclectic Italianate' style.

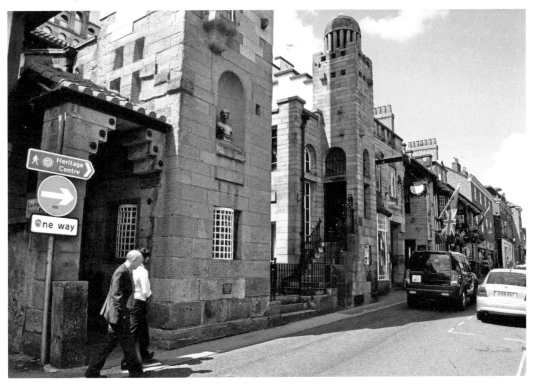

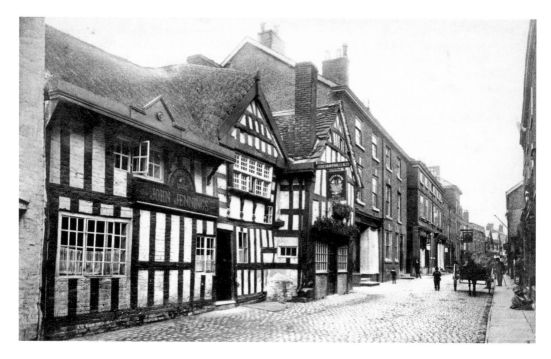

Rose & Crown, 1890 to 1900

Next to the Gaskell Tower is, in the old photograph, the seventeenth-century Rose & Crown public house, which in 1865 was owned by Thomas Lee, a Stockport licensee who also owned other businesses in the town. The pub had been used as dwelling houses and was in quite a rundown state. The 1860 *White's Directory* shows it as a pub, but closed. In 1896 the pub was sold to the Groves & Withnall brewery, the date 1641 can be seen on a plaque at the front.

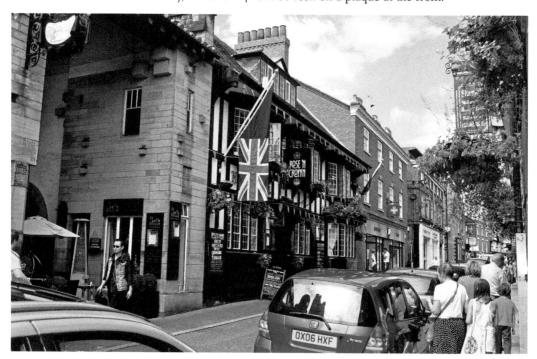

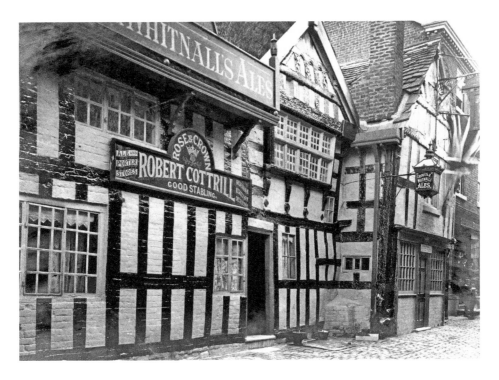

Rose & Crown, 1902

A closer look at this once-ancient pub, now owned by the brewery and with Robert Cottrill as the tenant. Shortly after this date, the brewery in their infinite wisdom demolished and rebuilt it in the style that can be seen in the modern photograph.

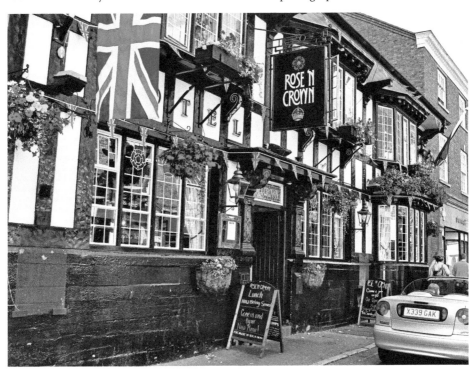

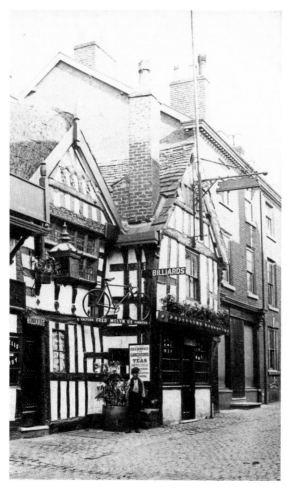

Rose & Crown, 1910 to 1925

A last look at this ancient pub. Above the door in the old photograph is a racing cycle with the name Fred Molyneux and Salford Harriers. This athletics club was founded on 5 March 1884 and is still going strong today. The premises of William Wildgoose & Sons draper's can be seen next to the pub but boarded up. They were probably moving to larger premises as the business lasted well into the twentieth century. This old Knutsford family were engaged in many enterprises and held community and council posts.

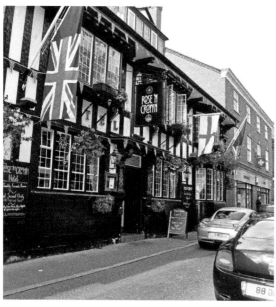

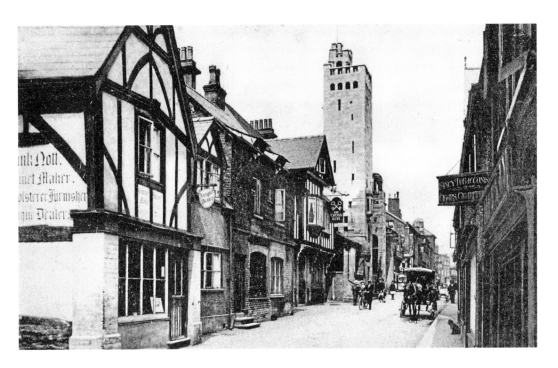

Gaskell Tower, 1910 to 1920

A view back towards the Gaskell Tower, built in 1907 to 1908. Immediately afterwards, the Kings Coffee House was built next door. Both were creations of Richard Harding Watt. The shop on the left belongs to Frank Nott, a cabinet maker and antique dealer. The modern photograph illustrates just how this busy road would benefit from being pedestrianised.

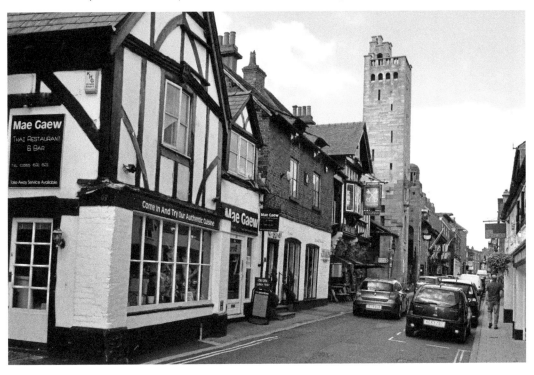

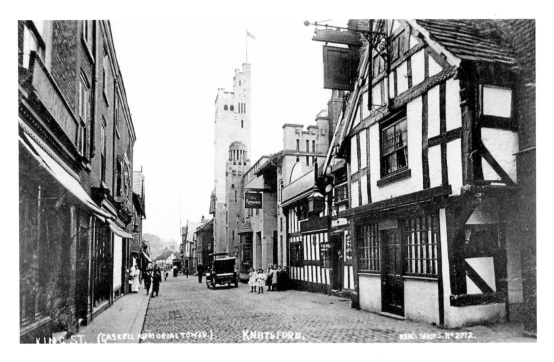

Rose & Crown, 1910 to 1915

Now we walk along King Street, pass the rebuilt Rose & Crown and look back at the Gaskell Tower. This is a truly atmospheric old photograph with the period car and the children's dress. It won't be long before this classic old pub will be torn down by a reckless brewery and rebuilt as an imitation of the original.

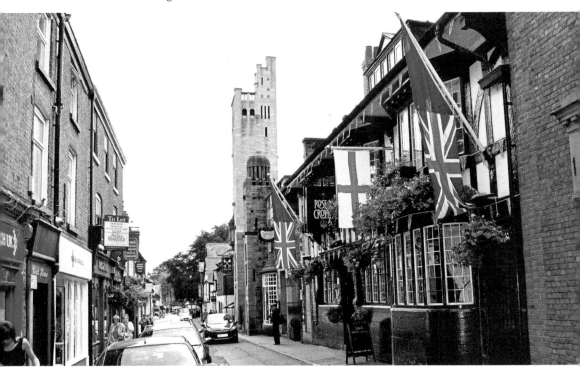

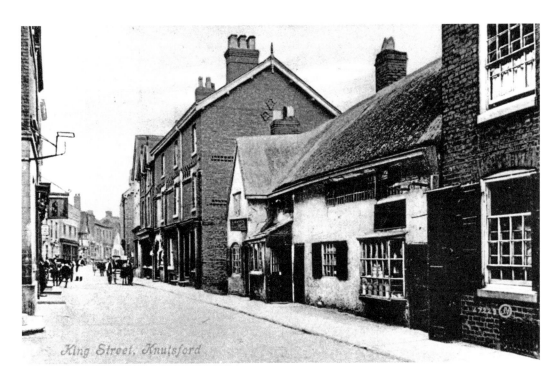

King Street, Knutsford

King Street Late 1800s Early 1900s

Here we see another piece of ancient Knutsford that has been demolished and replaced with something more modern. The old thatched row of shops has been replaced by the large redbrick building, now housing Barclays Bank and P. R. Jones jeweller's.

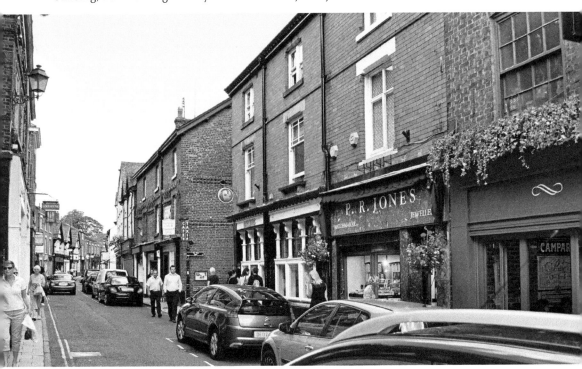

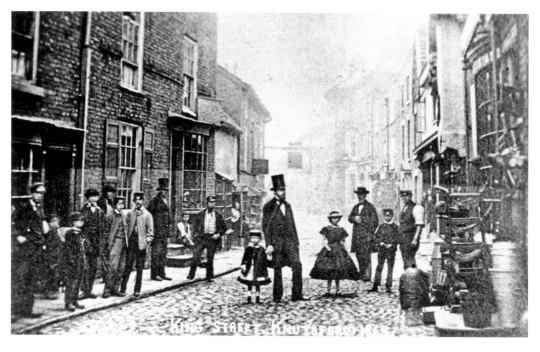

King Street, 1865

I apologise for the quality of this old photograph but as it is one of the oldest in the book there is a reason. It does give a feeling of Knutsford 140-odd years ago when the railway was just three years old.

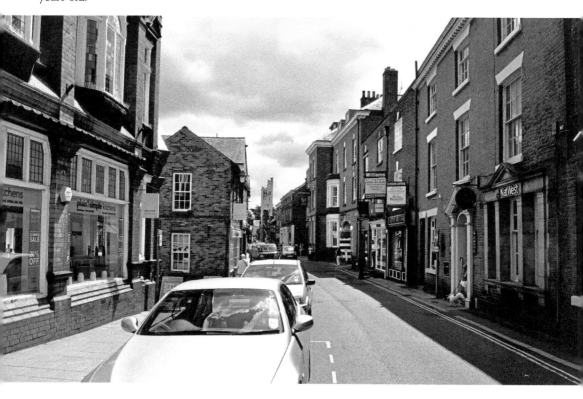

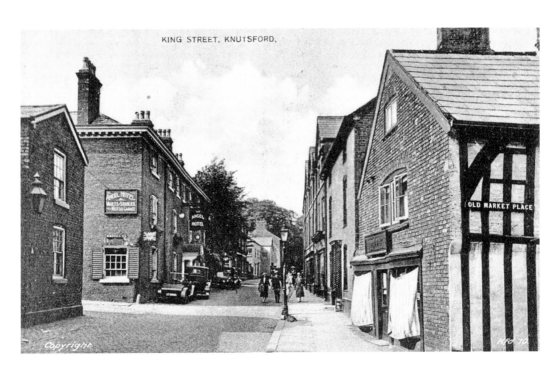

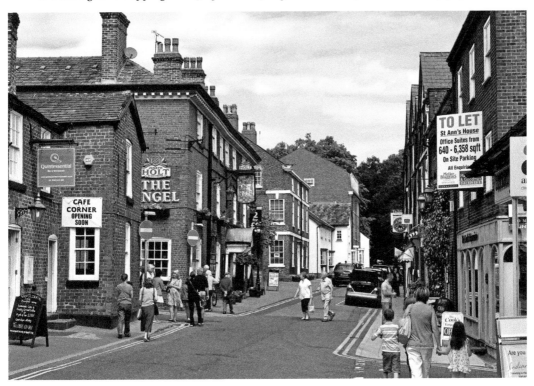

Angel Hotel, 1920s

Walking a bit further along King Street we come to this old hotel, which once catered for coach traffic. Amongst the coaches that stopped here 200 years ago was the Royal Mail from Liverpool to Birmingham, stopping at 10.30 p.m. every night. It is still open and still very popular.

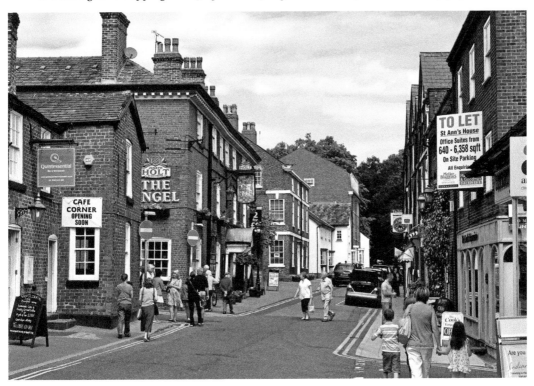

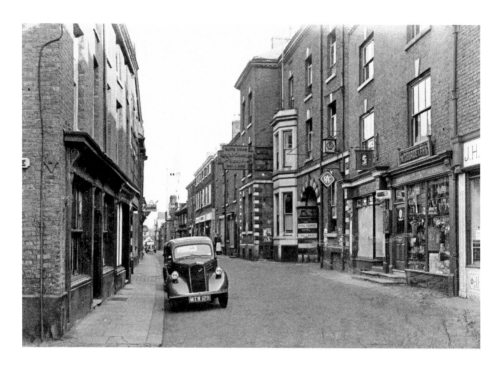

Royal George Hotel King Street, 1940 to 1949

Here we get a good view of another old coaching inn, the Royal George Hotel. The archway can be seen and at one time the words 'George Hotel' were written around the curve, but above this the word 'Royal' was applied at a later date. The reason for this was that in 1832 a young Princess Victoria visited with the Duchess of Kent and was so impressed with the service she received that the hotel was permitted to call itself the Royal George Hotel.

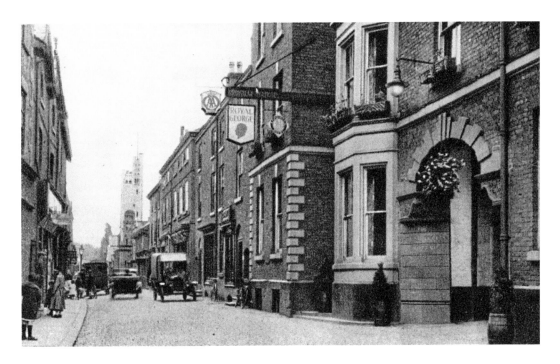

The Royal George, 1915 to 1920

Another look at this ancient coaching inn, which can trace its origins back to the eighteenth century. This was always an upmarket hotel with the Royal George Tap, its annex, at the rear in Princess Street, was provided for the staff of the gentry who stayed here. One of the coaches that stopped here was the 'Bang Up' from London to Liverpool which stopped at 4 p.m. and the 'John Bull' from Chester. The building now houses an upmarket fish restaurant, the Loch Fyne.

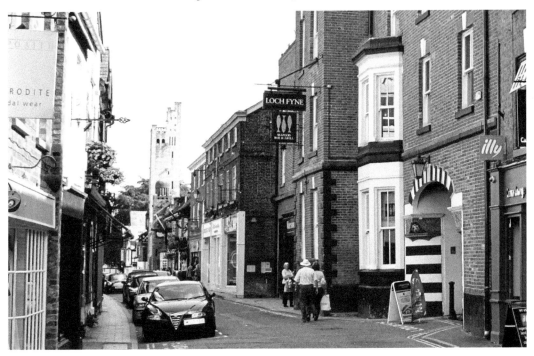

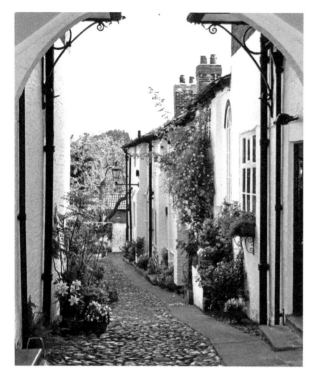

Marble Arch, King Street

Almost opposite the Angel can be found this archway leading to some pretty cottages, until around 1710 it led to an ancient coaching inn. This was called the Mermaid and then the Angel before being demolished and moved across the road. The steps for mounting the carriages can still be seen in both of these photographs; albeit in the modern shot flowers cover them.

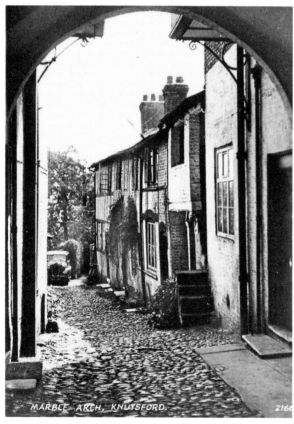

MARBLE ARCH, KNUTSFORD. 2166

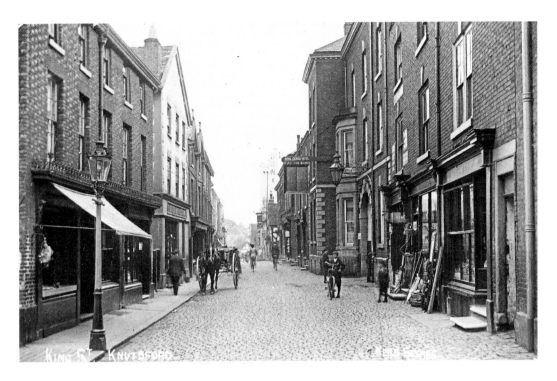

Mid King Street, Early 1900s

Back now for a last look at central King Street, The Royal George and the Gaskell Tower. This is such an excellent period photograph that I had to include it. The Gaskell Tower will have been brand new at this time.

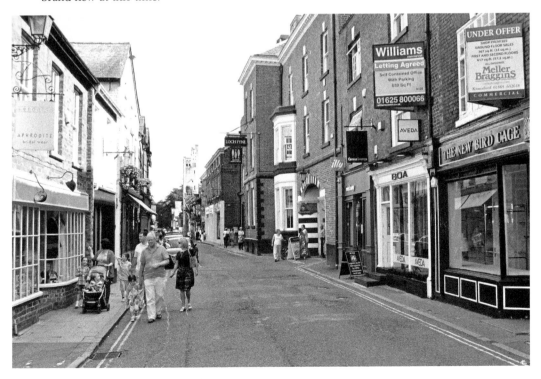

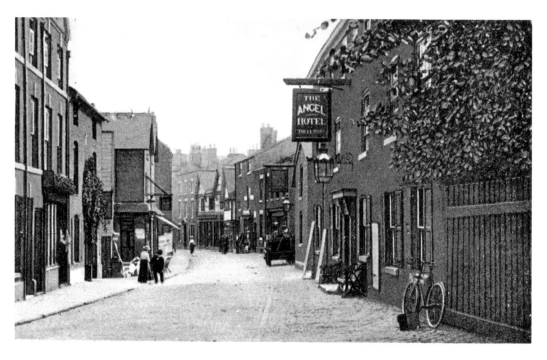

Into King Street from the Angel

This turn-of-the-century postcard has been hand coloured and in it you can see just how little has changed, especially on the right.

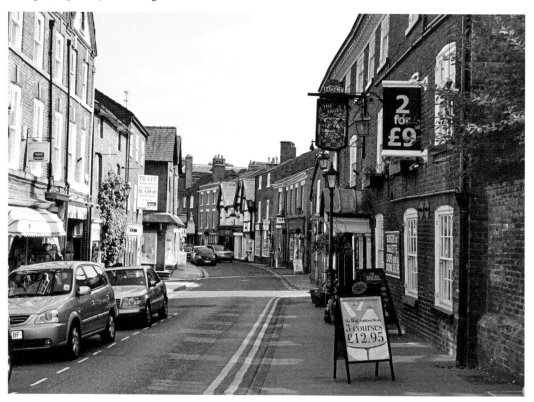

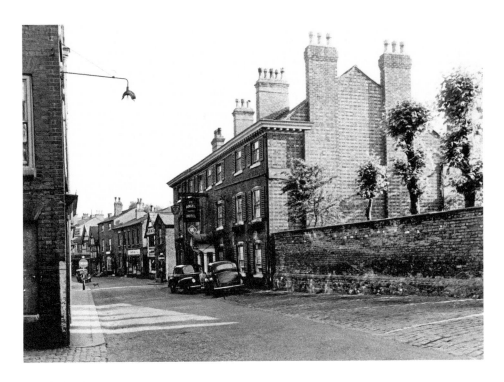

Angel Hotel, 1950s

A little more modern here as we see what King Street looked like in the 1950s. Period cars and a Ford van make up the sum total of the traffic. Things have changed over the years, and in the modern photograph there is a little more congestion.

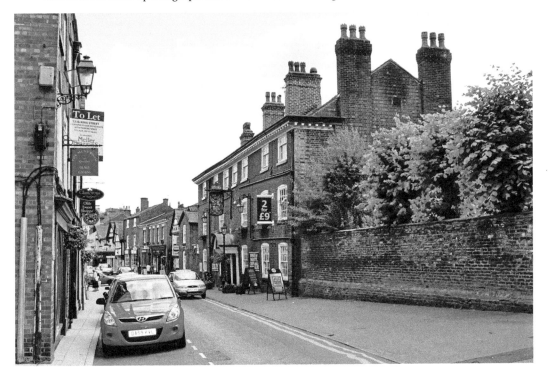

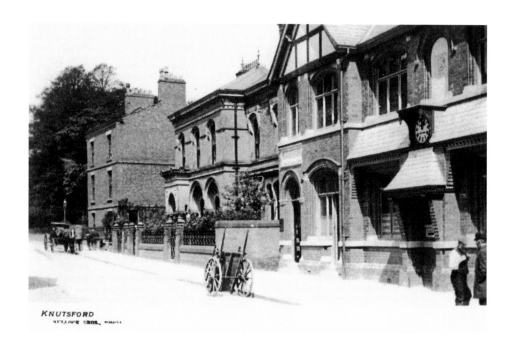

KNUTSFORD

Post Office, King Street, Late 1800s Early 1900s

The post office was purchased by Richard Harding Watt who intended to move it nearer to the town centre in one of the buildings that he planned there. He was met with indifference from the town council so he simply made a few alterations to the building, it remained as the post office for many more years and the phone boxes are evidence of this. There is still a clock on the wall is still there, although the older one has been replaced with a 'modern' version.

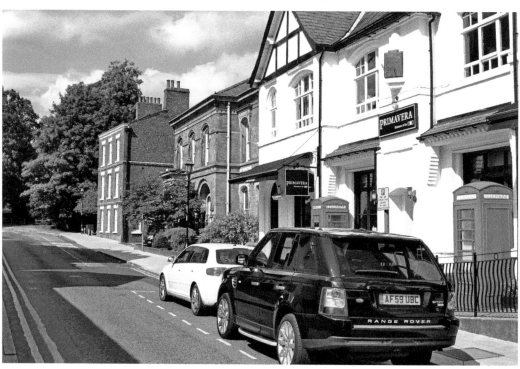

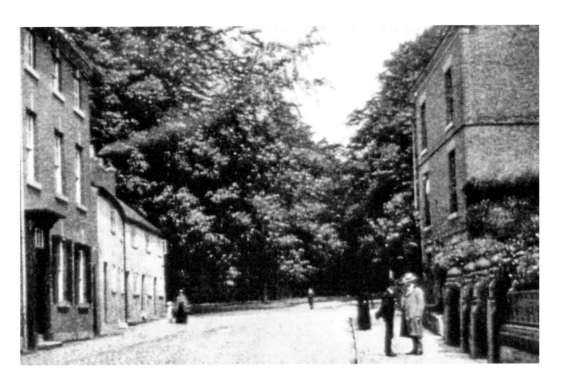

King Street End, Early 1900s

The large house on the right was built in about 1700 for a wealthy merchant and what stands out here is the fact that in the old photograph the house has three sets of two windows. The house was built with sets of three. The middle ones may have been bricked up to avoid the iniquitous 'window tax.' This tax came in before the house was built but was increased over the years, rendering it draconian. In 1851 it was abolished and presumably the windows reinstated.

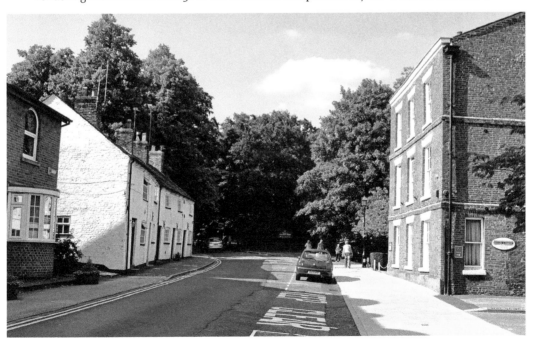

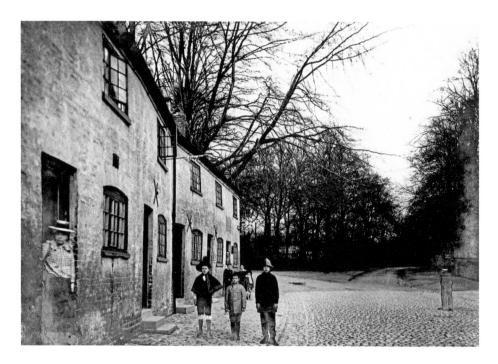

Approach to Tatton Park, Early 1900s

These ancient cottages at the north end of King Street are all that is left of the cottages that went all the way to the Tatton Hall gates. When the landscaping was being done they were described by Humphrey Repton, the designer of the imposing gateway, as 'miserable cottages'. Accordingly they were bought up and demolished. These were left and may at one time have been 'miserable' but are now very comfortable, as resident Val Dawson in the modern photograph will confirm.

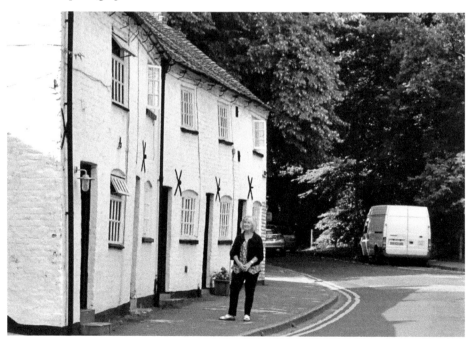

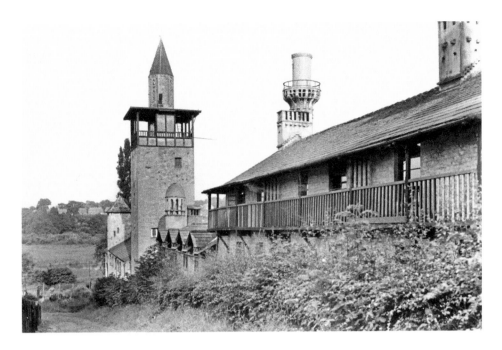

Old Laundry, Drury Lane, 1950s

We return to the work of Richard Harding Watt and one of his earliest creations. Originally a tannery stood here until Watt purchased the land and built this quite fantastic building along with the cottages for the workers. It originally had Byzantine domes and a minaret. The building now comprises two cottages and is a listed building. It seems that it is only long after his death that his work has been appreciated; it certainly wasn't by everyone during his life.

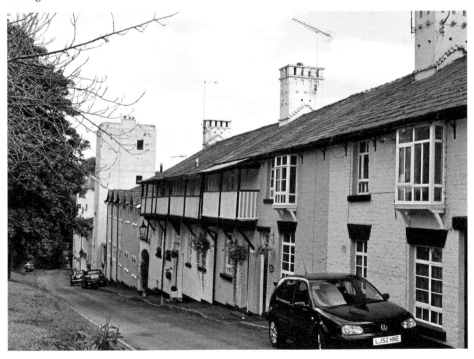

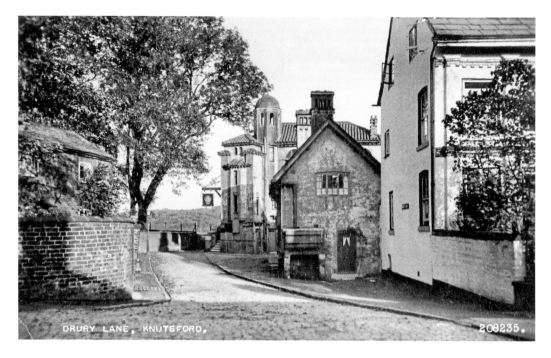

Drury Lane, 1919

Here we see the road leading to Watt's laundry and on the right can be seen the Ruskin Rooms, built as a tribute to John Ruskin in Watt's own inimitable style for the people of Knutsford. The building originally had reading rooms and a recreational area. It has also spent time as a fire station, headquarters of the British Legion and officers' club during the war. The white building on the right is the old vicarage built in 1693.

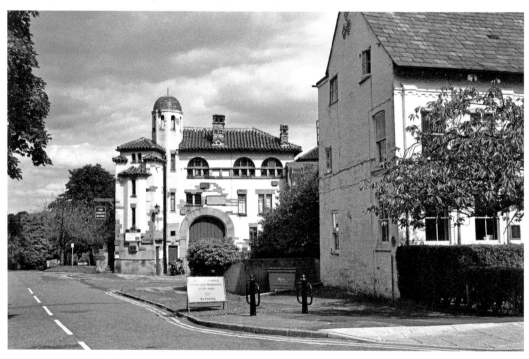

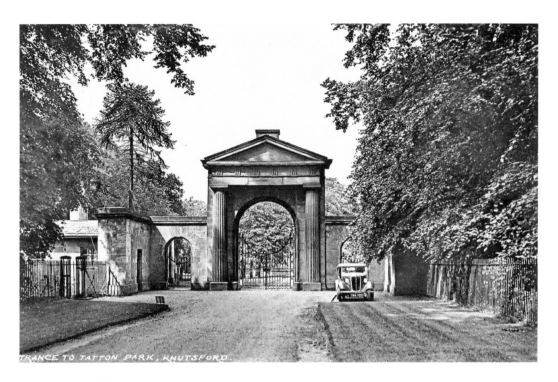

RANCE TO TATTON PARK, KNUTSFORD

Tatton Park Entrance, 1930s to 1940s

This spectacular gate is situated at the northern end of King Street and includes the gatekeeper's lodge. The splendid Tatton Hall is through this arch and over the years since the hall was built it has welcomed royalty, dignitaries and some 60,000 troops who trained here as parachutists during the Second World War.

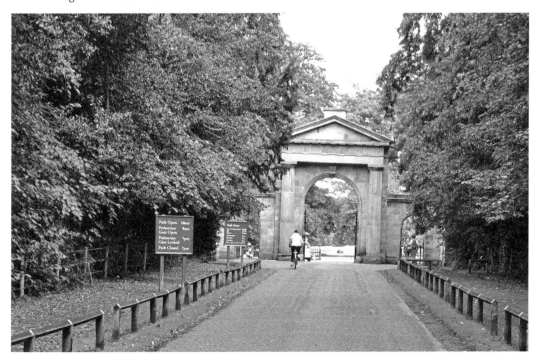

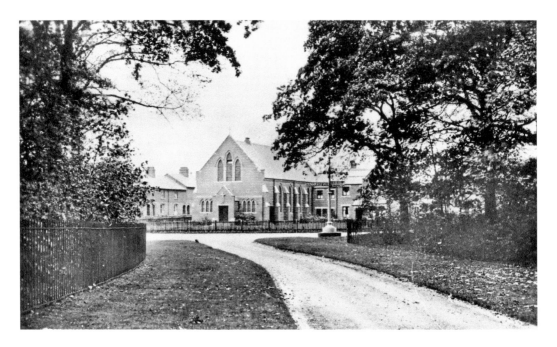

Catholic Church, Undated

Walking down from the Tatton Park gate we find the church of St Vincent de Paul. The new church was built on the site of the old one in 1981. The lamp standard on the corner, shown in the inset, is quite important as it is the last remaining one of the five tall iron lamp standards paid for by the Knutsford Freeholders in 1844. They remained unlit for around forty years. Apart from this one they were removed in the 1960s.

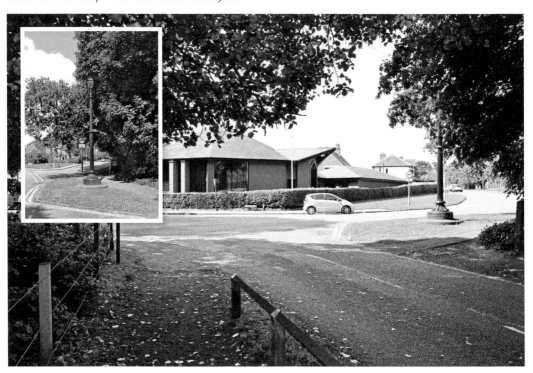

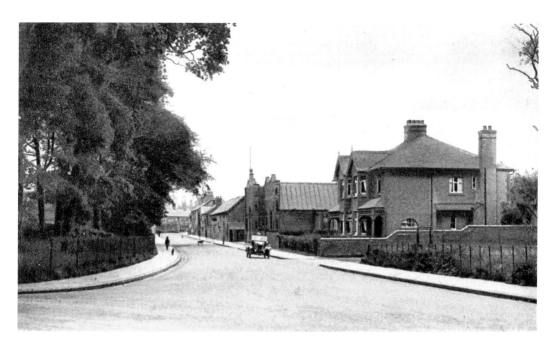

Into Tatton Street, 1920s

We stand now with our back to the lamp standard and, on the opposite side of the road to the church, a look into Tatton Street, which takes the traveller down to Canute Place. This is another hand-tinted postcard.

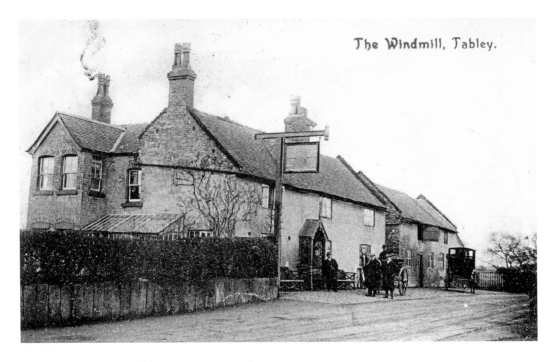

The Windmill, Tabley.

The Windmill Hotel, Tabley, Late 1800s, Early 1900s

We began this journey through Knutsford with an ancient pub and here we close with one on the same dual carriageway. The Windmill, like other pubs on this road, is named after a racehorse: in this case the one owned by Lord de Tabley, which won the Chester Gold Cup. It dates back to 1734 and when refurbished recently it retained its old character. Once on a relatively quiet turnpike road, it now sits at the junction of the busy A556 and the M6.

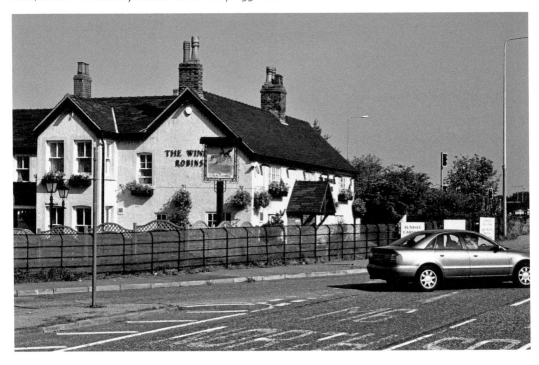